IMAGES
of America

BEAUFORT'S
OLD BURYING GROUND
NORTH CAROLINA

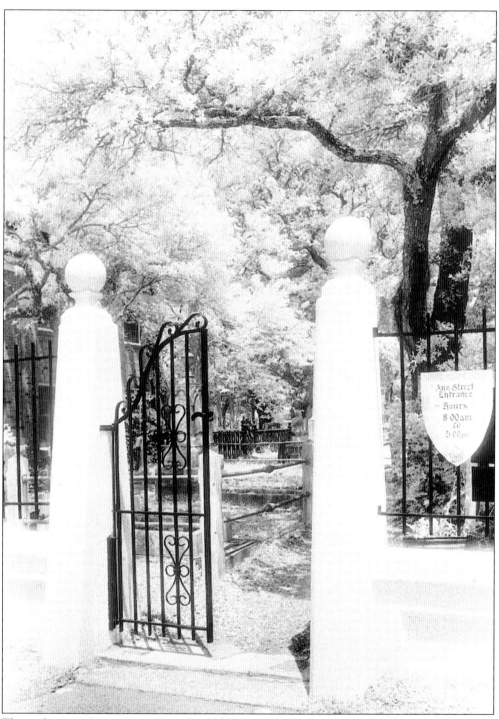

This is the Ann Street entrance to the Old Burying Ground.

IMAGES
of America

BEAUFORT'S
OLD BURYING GROUND
NORTH CAROLINA

Diane Hardy, Mamré Wilson,
and Marilyn Collins

ARCADIA
PUBLISHING

Published by Arcadia Publishing
Charleston, South Carolina

Printed in the United States of America

Library of Congress Catalog Card Number: 99-63945

For all general information contact Arcadia Publishing at:
Telephone 843-853-2070
Fax 843-853-0044
E-mail sales@arcadiapublishing.com
For customer service and orders:
Toll-Free 1-888-313-2665

Visit us on the Internet at www.arcadiapublishing.com

CONTENTS

DEDICATION

This book is dedicated to the many volunteers who have opened and closed the Old Burying Ground gate each morning and evening, and to the tour guides who give their talent and time to enrich the experience for schoolchildren and thousands of other visitors to the grounds each year.

The care and dedication of the tour guides and the Old Burying Ground Committee, who initiated major restoration in 1997, are critical to the preservation and maintenance of the grounds. The Town of Beaufort supports and entrusts the care of the grounds to the Beaufort Historical Association.

Pictured below is the bench in the Old Burying Ground, dedicated posthumously to Lyle E. "Sam" Samson. Sam and his wife, Lois, took care of the gate for many years. Lois continues to open and close the gate.

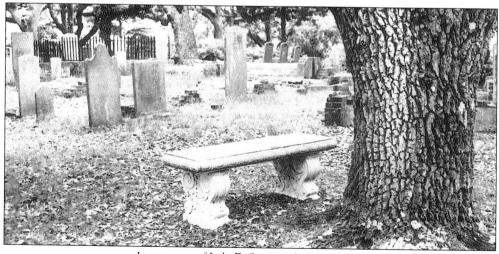

In memory of Lyle E. Samson (1920–1996)

ACKNOWLEDGMENTS

Research of family histories, documentation of the fading script on headstones, careful restoration of the markers, maintenance and security of the grounds, and visitor tours are lovingly handled by volunteers of the Beaufort Historical Association.

Much of the early research on the Old Burying Ground was conducted by Barbara O'Neill with continued work carried out by the Old Burying Ground Committee members associated with the Beaufort Historical Association. A deep debt of gratitude is owed to these dedicated people, without whom the grounds and markers would have slowly been overgrown and the lovely symbols and parting words long since faded. Thanks also go to the Town of Beaufort, owner of the Old Burying Ground, which appropriates funds each year for its care and maintenance.

We thank all those who have loved and cared for the grounds over the years and are especially grateful in this book to the following: Ralph Willis for his overall knowledge; Carol Willis, curator of the mourning collection for the Beaufort Historical Association; Bennett Moss, chairman of the Old Burying Ground Committee, and each committee member and tour guide; Paul Branch, historian at Fort Macon; Bob Hardy for his legal advice; Larry Collins for his editing assistance; Ruedrich Restorations for technical expertise; and the Carteret County Historical Society for their assistance in research materials for this publication.

Families in Carteret County have also enriched the book with their stories, photographs, and documents. Very special thanks go to each of them for sharing these treasures with us.

Lastly, we wish to thank and acknowledge the Beaufort Historical Association for their generous permission to use their archives and materials.

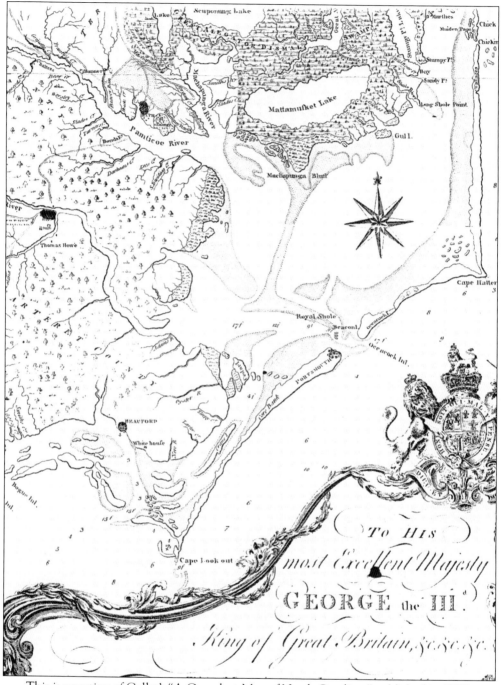

This is a portion of Collet's "A Compleat Map of North Carolina," published in 1770.

INTRODUCTION

A stroll down leaf-strewn paths of the Old Burying Ground, shaded by a canopy of ancient live oak trees, soothes the soul and stills the mind from the typical rush of daily life. All is peaceful.

However, as one begins to read the inscriptions, "Ye weeping parents weep no more," "Killed by a ball accident," "A kind and devoted husband, a dutiful son," "Ella bid her friends a final farewell," "In his public and private relations in life, his conduct was ever prompted by the motives of the patriot and philanthropist," and "God's finger touched him—and he slept," you begin to realize the energy of the husband and civic leader, physician, star-crossed lovers, and children whose lives were measured in hours, not days; each has a story to tell. Strong faith and belief in God sustained these people, as evidenced by the inscriptions and symbolic art used on many of the markers. Our purpose in writing this book is to give these stories life through pictures and to tell the tales and legends that surround their lives.

The Old Burying Ground is in the heart of Beaufort in Carteret County, North Carolina. Both the town and, separately, the Old Burying Ground are listed on the National Register of Historic Places. Established in 1709, Beaufort is the third oldest town in North Carolina. Visited by patriots, privateers, and pirates, Beaufort has a rich and exciting history. Recently discovered off the coast is a vessel thought to be the *Queen Anne's Revenge*, the sunken ship of "Blackbeard," the pirate. Artifacts are currently being recovered and catalogued under the direction of the North Carolina Maritime Museum, also in Beaufort.

More than 100 historic homes in Beaufort display plaques bearing the name of the original owner and date of construction. Often built by ship captains, the houses are sturdy and withstood storms and the wear of time quite well. Each year private homes and gardens are open to visitors during the Old Beaufort Tour of Homes and Gardens, sponsored by the Beaufort Historical Association. A special mourning exhibit is also open at this time. Death was a frequent visitor in those early years, and women were often in a perpetual state of mourning. On display are original period clothing and pictures, jewelry, and art created with human hair in remembrance of loved ones.

The Town of Beaufort was surveyed in 1713 and incorporated in 1723. This was during the reign of Queen Anne of England, nearly nine years before George Washington was born. Two streets are named in honor of the queen—Ann Street and Queen Street. Early English dialect is still heard Down East, a part of Carteret County cut off by water from the mainland for many of those early years of development.

Victims of early American Indian wars lie in unmarked graves in the Old Burying Ground, but the remains of split skulls and implements of battle record their fate. Early wooden markers

have mostly disappeared. Remaining examples have been treated and restored to withstand the moisture of this seacoast area. Best preserved markers are marble, often with a concrete-stuccoed, brick-masonry base. This book offers examples of restoration methods used by Ruedrich Restorations. Hopefully, these notes will caution those wishing to restore their own family markers to use cleaning methods that do not further contribute to existing damage. Readers may wish to seek the help of professionals for difficult restoration projects.

The focus of this book is to tell a portion of the history of Carteret County through the representative lives of those interred in the Old Burying Ground. These stories are simply told through photographs, inscriptions, and documents. So, sit back and enjoy exploring our past as we lead you through the Old Burying Ground and the tales it has to tell. If you have the opportunity to visit Beaufort, stop by the Beaufort Historic Site and enjoy touring this beautiful spot where the past and present commingle to form the rich history of this lovely seaside town.

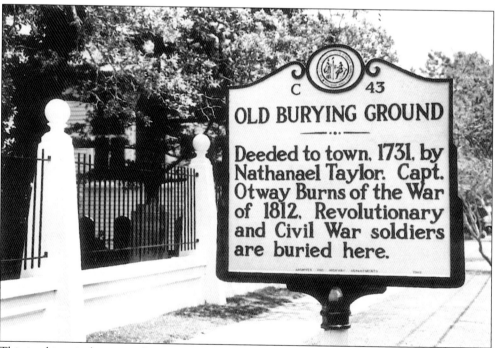

This is a historical state marker on Ann Street.

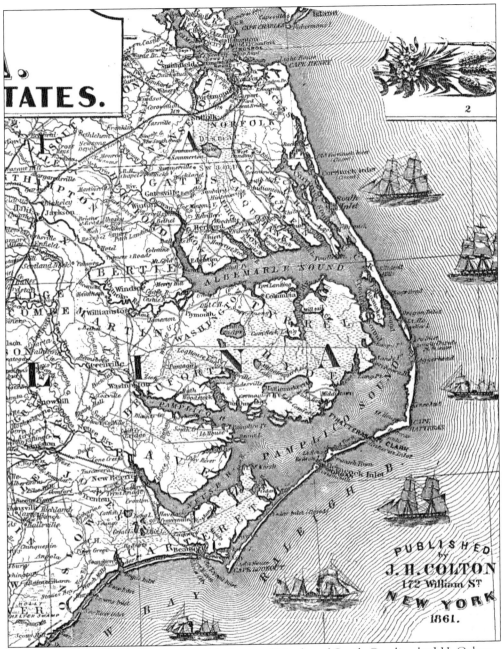

Here is a portion of the 1861 topographical map of North and South Carolina by J.H. Colton.

The streets of Beaufort are lined with lovely old homes fronted by porches with welcoming rocking chairs. Pots brimming with flowers add a splash of color behind the white picket fences bordering many of these homes. Stroll the shade-dappled sidewalks, which invite you to explore this historic fishing village. The early charm of this town remains unmarred and welcomes visitors to enjoy its history, architecture, and its easier pace of life.

One

HISTORIC SETTING

There is a world above
where parting is unknown
Formed for the good alone
And faith beholds the dying here
Translated in the happy sphere

—William Jones, c. 1850

Located on Ann and Craven Streets, the Old Burying Ground reflects the good times and the hard times of this community. Coree Indians were an early Iroquois-speaking tribe of the Tuscarora who lived in Beaufort and surrounding areas. Evidence from a 1711 uprising documents the earliest burials. Wooden markers, followed by marble, trace the improvements in monument development. Three corners of the ground are marked by churches—Purvis Chapel (c. 1820), Ann Street Methodist Church (c. 1854), and the First Baptist Church (c. 1854). Photographs of the churches show how Beaufort appeared in earlier days.

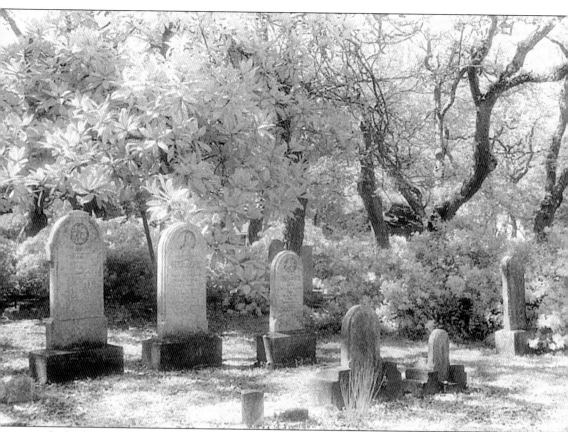

Bathed in sunlight, the Old Burying Ground lies peacefully under the protective branches of live oak trees. Azaleas and wisteria bloom in the spring, giving added beauty to this quiet place. Natural sandy paths lead visitors on secluded, private walks. Or, one may join a tour led by docents from the Old Burying Ground Committee of the Beaufort Historical Association. To paraphrase, "A place of beauty is a joy forever."

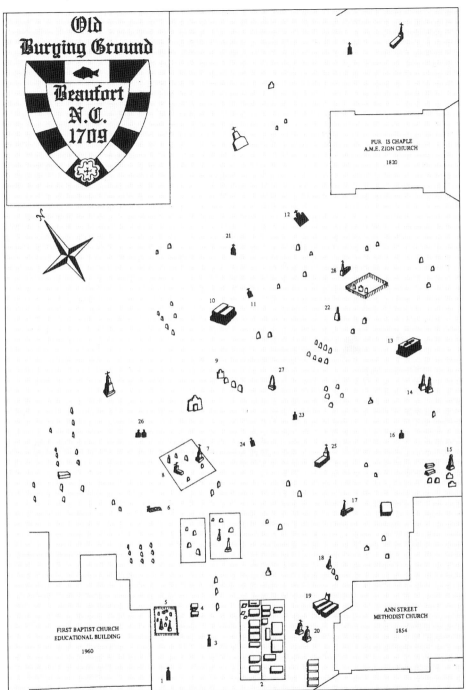

Approximately 600 markers are in the Old Burying Ground. This simplified grid gives an overview of the general layout and location of historic churches bordering the grounds. You may note that graves mostly face east in anticipation of facing the sun on "Judgment Morn." Shell, brick, or wooden slabs preceded marble markers, which had to be brought from Europe by wooden sailing vessels. The vaulted cement and brick coverings provided protection from wild animals and high water from storms.

15

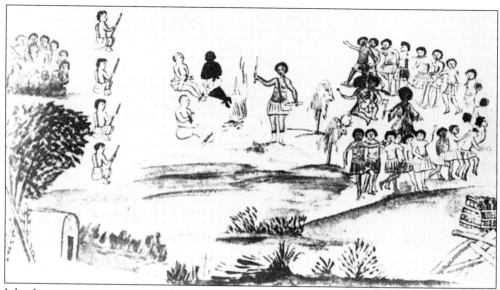

John Lawson was a surveyor and land grant owner living near New Bern in adjoining Craven County, North Carolina. He was captured at Fort Barnwell by the Tuscarora Indians in 1711 as he led an expedition to locate a road through Tuscarora territory. The Tuscarora War lasted until 1713, when a final battle broke the power of the Tuscaroras. The majority of this powerful tribe moved to New York and became the sixth nation of the Iroquois Confederacy.

This portion of *The Drawings of John White* (1577–1590) depicts an American Indian village showing the organization used by the Indians in conducting their daily lives.

The oldest marker (1756) in the Old Burying Ground is simply marked "A.P." Unmarked graves date from as early as 1711, most likely from the Indian massacre of that date.

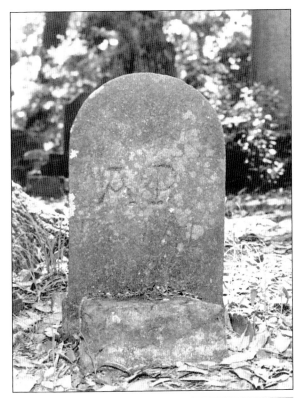

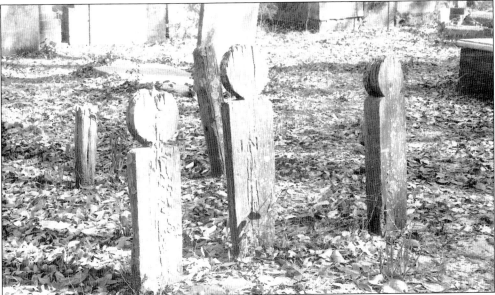

Small wood markers still exist in the Old Burying Ground. Efforts have been made to postpone further deterioration of these primitive markers in an attempt to keep in future memory the names and lives of people buried here. A hot solution of linseed oil and turpentine was used by Ruedrich Restorations to treat the markers. The ground around the base was treated with Durisban to prevent further deterioration and insect damage. (See Chapter 6 for other restoration notes.)

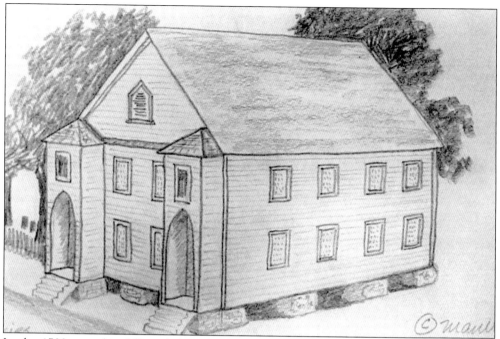

In the 1700s, worship followed the Church of England for most people living in Beaufort. Today, three corners of the Old Burying Ground are occupied by churches, each with its own history. Services in the Methodist Church (pictured above is an artist's concept [c. 1820], © 1999, Mamré) were often held by circuit riders, some of whom are buried in the Old Burying Ground. Former Methodist ministers include Bridges Arendell, John Jones, John Rumley, and J.T. Arrington. In 1834, the Reverend James Purvis led a soul-stirring revival that inspired the congregation to rename the church Purvis Chapel. Purvis Chapel was given to the black community in 1854 when Ann Street Methodist Church was built. Purvis Chapel remained with the Methodist Episcopal Church South until 1864, when it affiliated with the A.M.E. Zion Church. The First Baptist Church, chartered in 1851, stands on the southwest corner of the burying ground. Services were first held in the newly completed building in 1854.

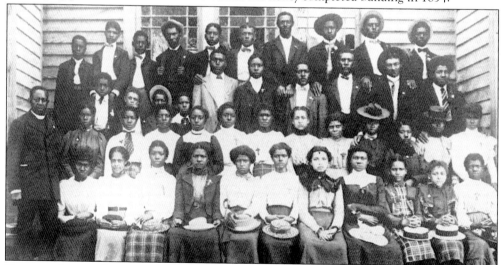

Congregation members pose for a group picture in front of Purvis Chapel (c. 1900).

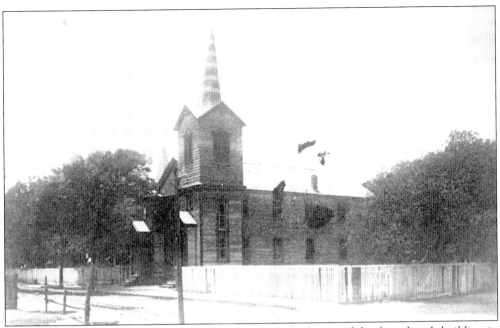

The photographs on this page show the architectural evolution of the first church building in Beaufort, now known as Purvis Chapel. Note that the steeple (c. 1900) has been added.

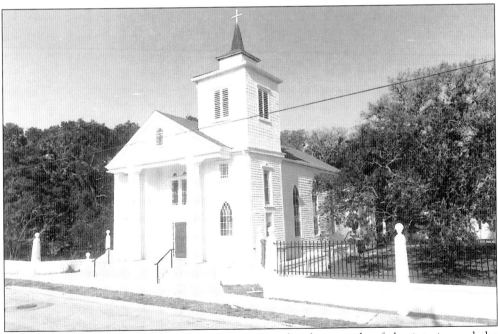

This is the Purvis Chapel today. Major restoration has been made of the interior and the exterior of the church. A new Heritage Room has been added to preserve the history of this significant landmark.

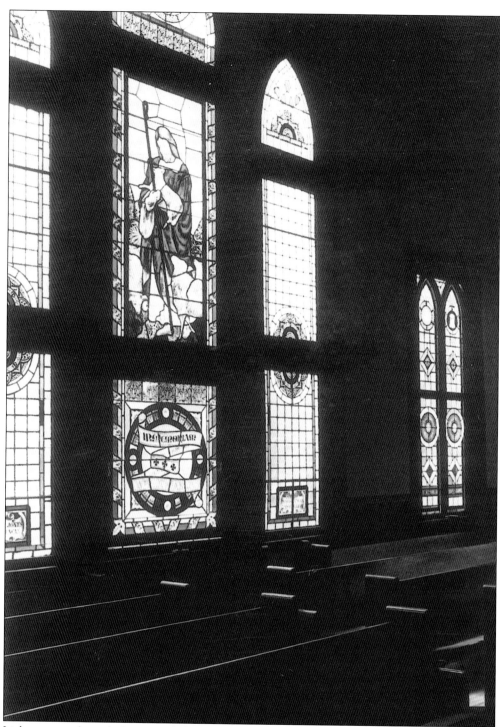

Light streams through the stained-glass window of Ann Street Methodist Church. This window was given in memory of W.B. Duncan Jr. (1874–1892).

This door on the Ann Street side of the church was used as the access to the sanctuary by the choir. The choir did not process after vesting. They would leave the choir room on the Craven Street side, walk around the corner, and enter through this door to the choir loft for services.

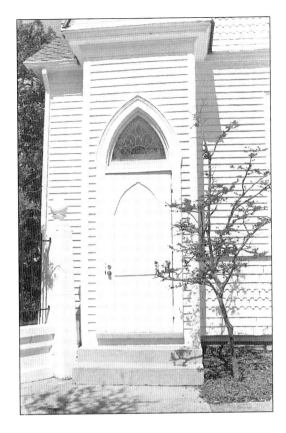

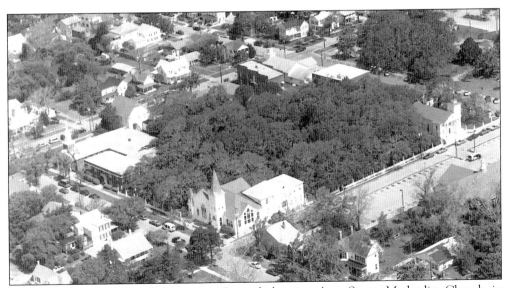

This is an aerial of the Old Burying Ground showing Ann Street Methodist Church in the foreground.

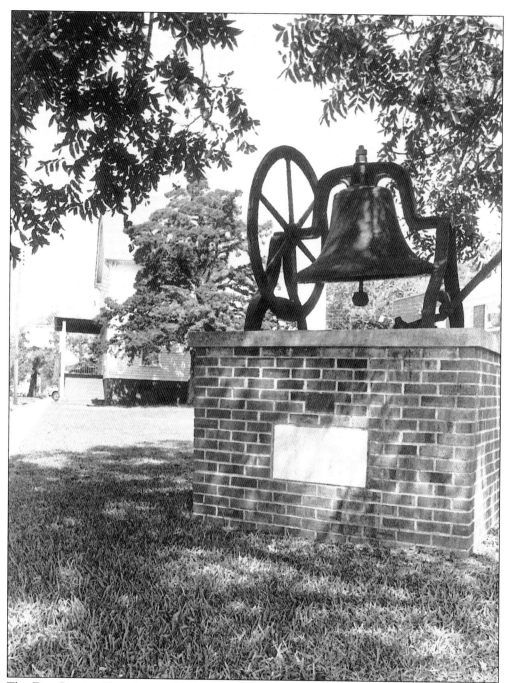

The First Baptist Church was chartered in 1851. The congregation met in various buildings until their new church was completed in 1854. During the Civil War, the building was used by Federal soldiers for various purposes. The bell that hung in the original building is now mounted at the corner of Turner and Ann Streets. It was given in memory of Sarah C. Guthrie (April 6, 1910–May 18, 1982) by her husband, Claud. In the background stands the Masonic Lodge (c. 1855), which was the Beaufort Female Academy before becoming the home of the Franklin Masonic Lodge in 1895.

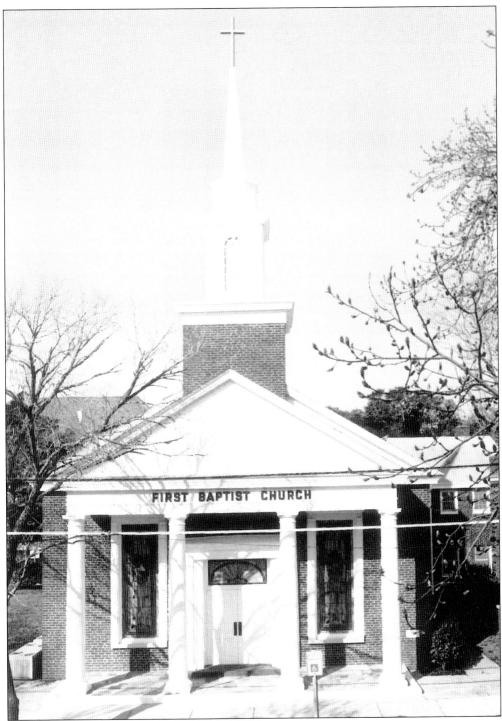

This is the First Baptist Church today. Additions were made to the original structure from 1887 through 1914. In 1953, a new brick structure was completed. The Educational Building was erected in 1960 on the site of the original building. The life of Christ from birth to resurrection is depicted in the stained-glass windows of the church.

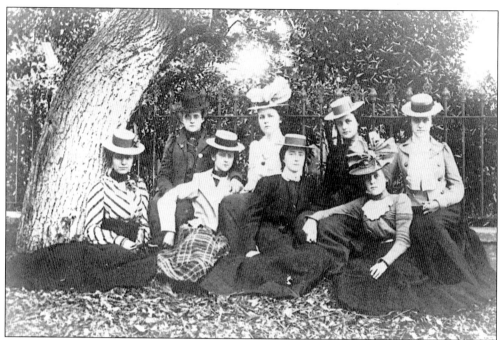

With almost matching hats and expressions, these women pose for their picture in the Old Burying Ground dressed in the finest fashion of the day (*c.* 1900).

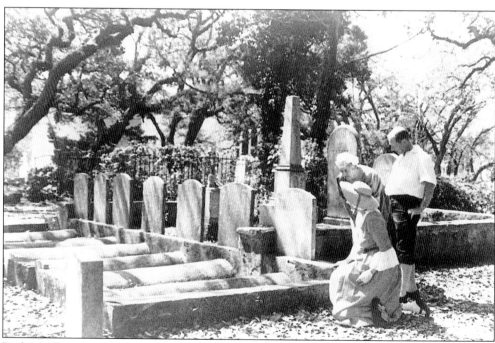

Dick Meelheim and docents Delores Meelheim and Barbara O'Neill survey family plots in the Old Burying Ground. In the background, azaleas bloom and resurrection moss hangs from the live oak trees adding beauty to this peaceful place.

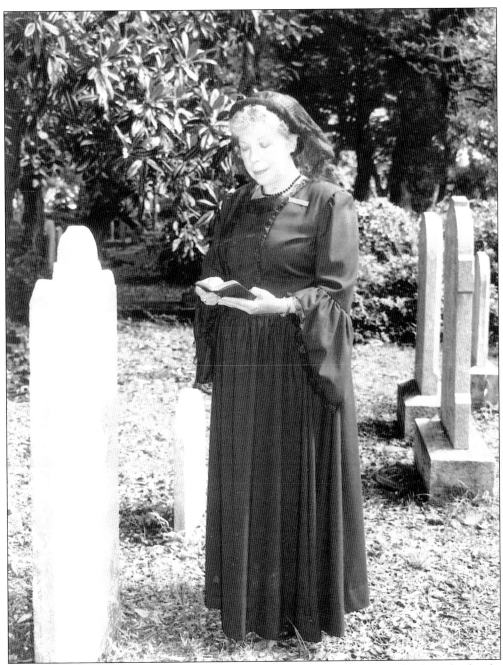

Louise Nelson, a local resident, recalls that in Beaufort when there was a death in the family, her grandmother wore a little, black pillbox hat made of silk. The veil was worn completely around the head for six months. After the sixth month, the front part of the veil was lifted and placed on the back of the head. The hat was worn this way for the remainder of the mourning year. When someone died, no clothes were hung on the line, no yard work was done, and the children played quietly until after the funeral. No Christmas tree was placed that year, although cookies could be put out for Santa Claus. Carol Willis, shown here in typical mourning garb, is the curator of the Beaufort Historical Association's mourning exhibit.

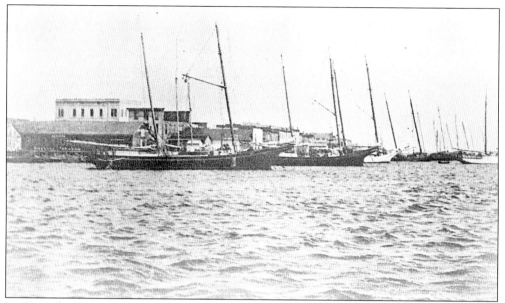

In the early days, most travel was done by boat, as there were few interior roads and bridges. Boats of all sorts have always been attracted to the Beaufort harbor. Pictured are most likely sailing packets used to transport goods and people between Beaufort and other ports along the Eastern Seaboard. Waters surrounding Beaufort have played an important role in the history of the town and the nation. Five flags have flown over Beaufort. Originally, Beaufort was under the British flag, briefly under the Spanish flag in 1747, the Stars and Stripes in 1777, in 1861 under the Confederate flag, and the Federal flag in 1862. Pirates, privateers, and warships—both foreign and domestic—have all sought for advantage along these shores.

Piver is one of the oldest names in Beaufort's history. In 1709, Peter Piver Sr. came from England to Carteret County and helped settle Fish Towne at the western end of Beaufort. This picture of Front Street in Beaufort was taken in the early 1900s from Piver's Island, the current home of marine laboratories of the National Oceanic and Atmospheric Association and Duke University.

Urban renewal in the 1970s demolished these buildings shown in a 1941 photograph of Front Street (facing east). Buildings sat on pilings over the waters of Taylor's Creek, which runs parallel to Front Street. The look of Front Street is different today, but much of the character of these buildings remains due to preservation-minded town leaders, residents, and business owners.

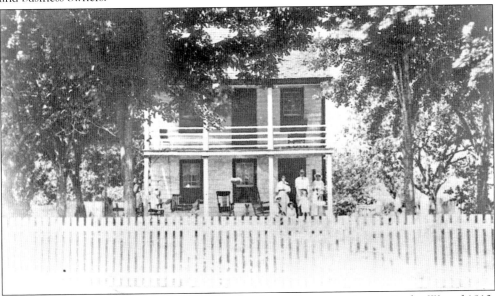

This typical Beaufort house was once owned by Otway Burns, a privateer in the War of 1812. Born in 1790, Burns moved to Beaufort as a young man and operated a "coaster" on the Neuse River between New Bern, North Carolina, and Portland, Maine. His shipbuilding business constructed the first steamboat, the *Prometheus*, to work the waters of the Cape Fear River. In 1821, Burns entered politics, serving seven years in the North Carolina House of Commons and five years in the North Carolina Senate. (More information on Burns is in Chapter 3, "Voices of War.")

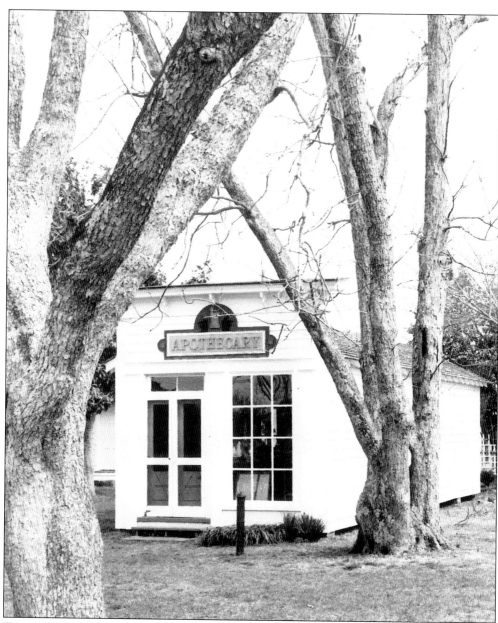

Tours of the Old Burying Ground are conducted during summer months by volunteers of the Beaufort Historical Association. The historic site is on the corner of Ann and Turner Streets, and additional tours are given throughout the year of buildings constructed from c. 1732 to c. 1859. These buildings include the Joseph Bell House (c. 1767), Josiah Bell House (c. 1825), Carteret County Courthouse of 1796 (the only eighteenth-century frame courthouse of its size in North Carolina that can be restored), Apothecary Shop (c. 1859), Carteret County Jail (c. 1829), and the Samuel Leffers's Cottage (c. 1778). Docents in period clothing conduct narrated house tours as well as tours of the historic district atop a Leyland 1948 English double-decker bus. The Robert W. and Elva Faison Safrit Historical Center welcomes visitors to enjoy displays of historic events, artifacts, and skills indigenous to the area. Pictured is the Apothecary Shop and Doctor's Office (c. 1859).

Two

STORIES AND LEGENDS

Leaves have their time to fall
and flowers to wither at the North wind's breath,
And stars to set . . . but all,
Thou has all seasons for thine own,
O, Death.

<div align="right">Annie Beauregard Gabriel, c. 1885</div>

In this town steeped in history, stories abound of daring sea exploits, star-crossed lovers, spies, shipwrecks, religious pioneers, midnight burials, and much more. This chapter contains sample tales told and retold through the years. Feel the freezing rain on your face as you witness the death of those brave sailors aboard the *Crissie Wright*, or picture the midnight burial of another young man drowned at sea. Sounds and smells, tears and prayers echo through each story told.

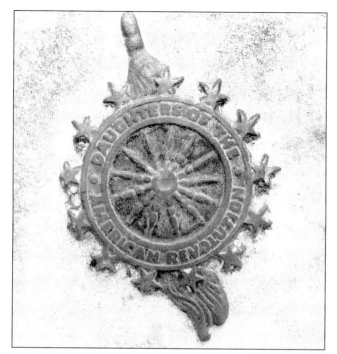

Nathan Fuller (1750–1800) served in the Revolutionary War as an ensign in the Carteret County Militia. The shape of his monument represents the gates leading into heaven. Note the enlarged DAR emblem depicting a spinning wheel surrounded by 13 stars. Brick covering the grave was used to hold the casket in place during heavy rains in the sandy soil of coastal North Carolina. A footstone as large as the headstone is unusual (shown below).

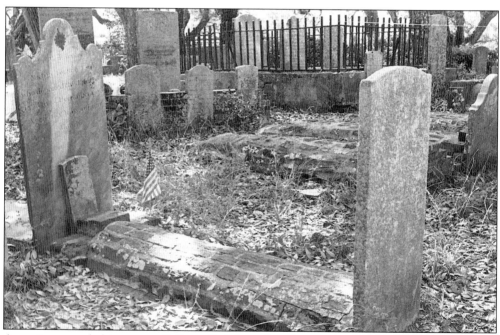

A navigator and ship owner, Fuller sailed from Beaufort to the West Indies, England, and Barbados bringing supplies into Beaufort harbor prior to the Revolutionary War. In 1779, he owned "100 acres, two Negroes, 15 cattle, half a lot and 920 pounds." By 1784, his landholdings had increased to 400 acres. He was elected to the North Carolina House the following year. He married Mary Pacquinett, whose family helped establish the Core Sound Quaker Meeting House, now a Methodist church on Highway 101 in Beaufort.

When Fuller died in 1800 at the age of 50, he left his wife Lot No. 23, on which stand the Borden House, *c.* 1769 (pictured right), now the Cedars Bed and Breakfast on Front Street in Beaufort, and the Belcher Fuller House, *c.* 1852 (pictured below).

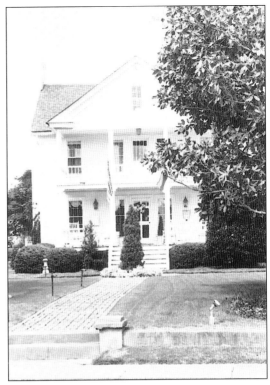

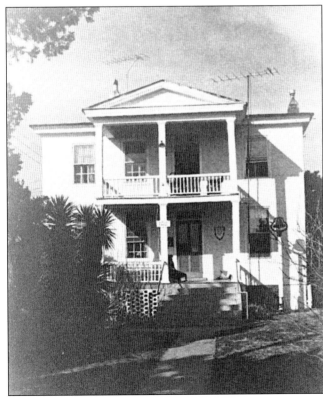

The Belcher Fuller House incorporated the house of Belcher's father, Nathan.

Josiah Bell (1767–1843) was a justice of court, a tax lister, and a member of several commissions. A year prior to his death, Josiah stated in his will that his son William was to have his "Negroes and Newport land" plus half of his land on the North River. His daughter, Charity Davis, was given a plantation called Harris Plantation and the land called Bell's Chapel. Josiah Fisher Bell (also buried in the Old Burying Ground), his youngest son, was to receive "Negroes, various lots and the house in Beaufort," which still stands today on the Beaufort Historic Site. Josiah Fisher Bell was the collector of customs prior to the Civil War. He served as an agent in the Confederate Secret Service. In 1864, he was responsible for making arrangements for Confederate troops to enter the county, make their way to Cape Lookout, blow up the two lighthouses, and leave the county without being caught.

Josiah Fisher Bell was born in 1820 and died 70 years later. He married Susan Benjamin Leecraft, and they had six children. Several Leecraft houses still exist in Beaufort that were built by her father.

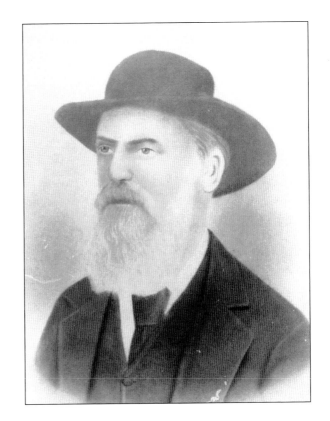

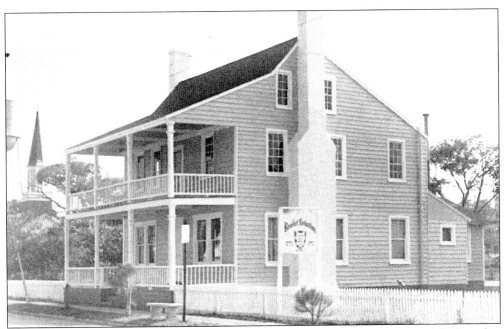

The Josiah Bell House (c. 1825) is open for daily tours led by costumed docents of the Beaufort Historical Association. Furnished in a comfortable Victorian style, the house is part of an overall building tour that encompasses structures built from c. 1732 to c. 1859.

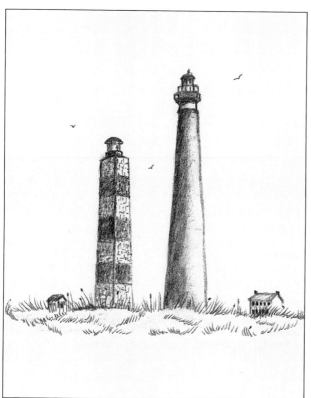

In 1864, Mary Francis Chadwick, a local spy for the Confederacy, reported that Union troops were to be stationed at Cape Lookout for protection of the lighthouses. Upon receiving this news, Josiah Fisher Bell met with Confederate troops from Kinston and plotted to blow up the lighthouses. Crossing several miles of hazardous open water to the Cape, they successfully destroyed the original lighthouse and severely damaged the second. Pictured is the older lighthouse (c. 1810), which was brick inside with wood frame and shingles on the outside. Also pictured, the newer structure (c. 1859) was most likely brick covered with plaster. The distinctive diamond markings were added in 1873. (Artist's concept, ©1998, Mamré.)

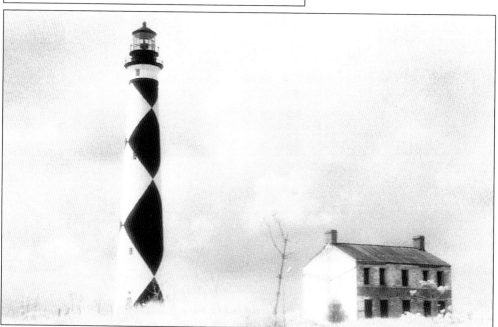

A lighthouse has been in operation at Cape Lookout since 1811. Its keeper's quarters still stand today. Other North Carolina lighthouses were patterned on this structure. The lighthouse keeps solemn watch warning ships away from the treacherous waters known as the "Graveyard of the Atlantic."

As a Methodist minister and "circuit rider," Reverend Bridges Arendell (1782–1850) took the gospel from community to community in Carteret County. He built the first church at Shepard's Point, which was used during the Civil War as a bakery by Union troops. Arendell and his wife, Sarah Fisher Jones, inherited Shepard's Point from her father, William Fisher. This land later became Morehead City.

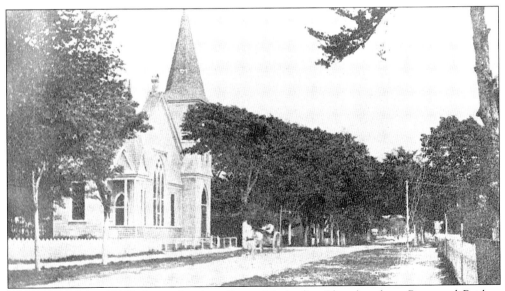

This postcard (c. 1910) shows the Ann Street Methodist Church, where Reverend Bridges Arendell conducted services.

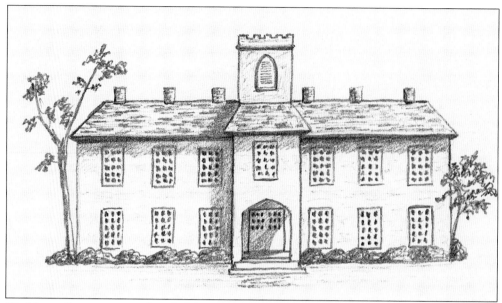

Washburn Seminary was founded between 1864 and 1867 by the American Missionary Association and the northern Congregational Church. All that remains today is the workshop (pictured below) where students were able to learn a trade. (Artist's concept, ©1998, Mamré.)

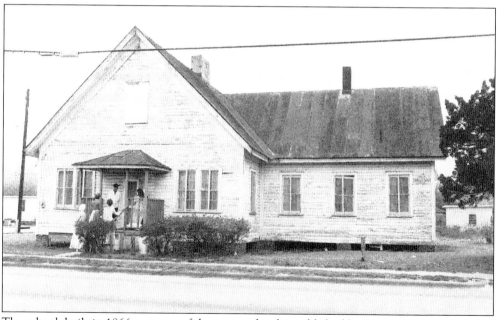

The school, built in 1866, was one of the many schools established by Congregational churches of the North following the Civil War. This structure was used as a workshop by students. Both Washburn Seminary and St. Stephen's Congregational Church were highly regarded Black institutions in Beaufort during the Reconstruction Period. Pierre Henry and his wife, Annie Henry, were African-American leaders in the education of emancipated slaves and their children. He served as a trustee of Washburn Seminary in 1866.

Pierre Henry was born during the period of slavery. In 1800, there were 122 slaves in Beaufort of a total of 559 residents. By 1820, there were 34 free blacks and 547 slaves. By 1860, there were 59 free blacks and 579 slaves with a town residency of 1,610. By 1860, five free blacks owned property. In the years of 1860–1870, the black population doubled.

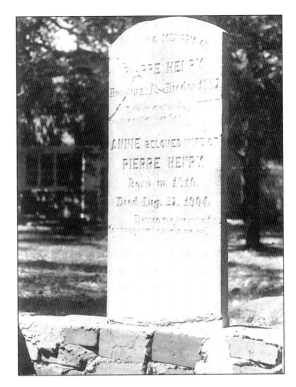

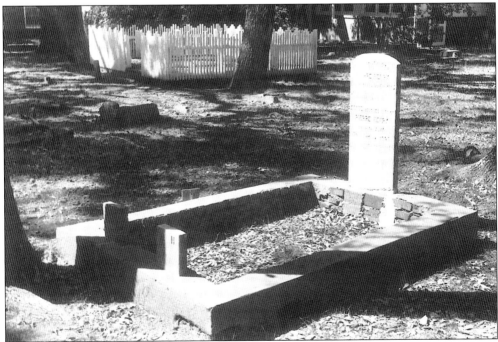

Pierre Henry (1812–1887) and Annie Henry (1816–1904) are buried side by side. Note their initials on the footstones. Their epitaphs are both from the *Beatitudes*, "Blessed are the pure in heart / for they shall see God," and for Annie, "Blessed are the merciful / for they shall obtain mercy."

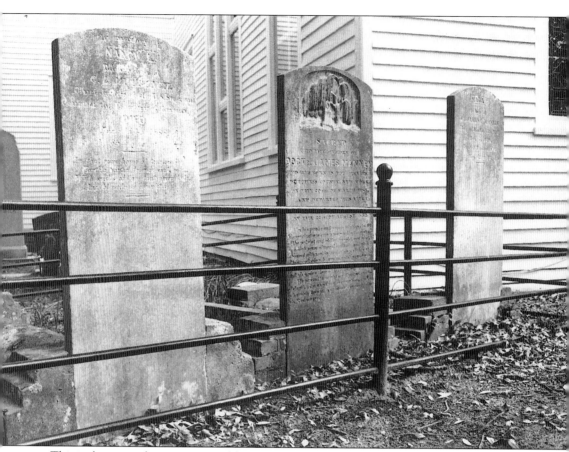

This is the story of two star-crossed lovers—Nancy Manney (1820–1886) and Charles Grafton Wilberton French. After his education in several New England schools, Charles came to Beaufort, where he met and fell in love with Nancy. Her father was opposed to the marriage, preferring that Nancy stay home to care for her seven younger siblings. Frustrated with this opposition, Charles moved to the Territory of Arizona, where he read law.

Charles continued to pursue Nancy, but his letters went unanswered. He married a widow with two children and rose in his profession to the associate justice of the Supreme Court of the Territory. After Mr. French's wife died, he decided to write directly to the postmaster in Beaufort asking about Nancy. Story has it that the postmaster confessed to holding Charles's letters to Nancy on the request of her father and wrote back urging Charles to return to Beaufort.

Charles did return to Beaufort, and on May 20, 1886, Nancy and Charles were married.

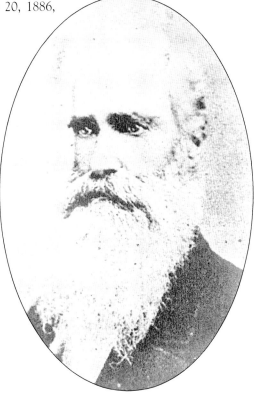

Though separated by many miles and many years, Nancy Manney remained true to her love until, by a quirk of fate, they were united. Sadly, she died from galloping consumption almost a month after their wedding day on June 14, 1886.

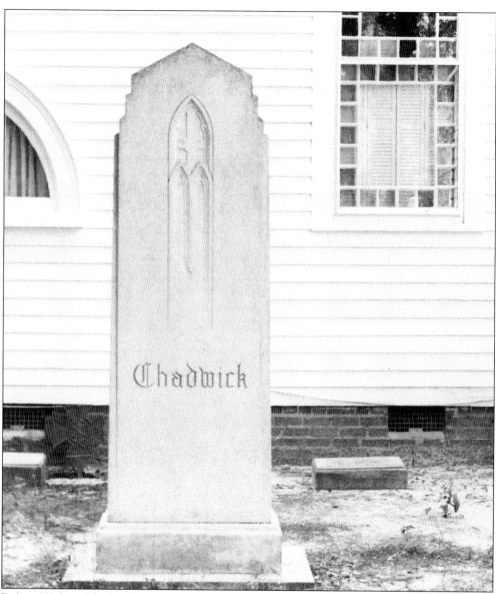

Robert Withers Chadwick (1826–1884) married Mary E. Potter (1832–1897). The stone above marks the family plot. They lived in Wilmington, North Carolina, where Robert was the collector of customs. In this role, they entertained many sea captains. Local legend has it that a young Chinese stowaway was brought to Mary's attention. She could not stand for him to be deported, so they took him in and later provided for his education at Trinity College, now Duke University. He returned to China as a missionary, married, and, so the story goes, became the father of the Soong sisters—Mme Chiang Kai Shek and Mme Sun Yat Sen.

A nephew of Robert Withers was Winfield Scott Chadwick, also buried here, who joined the Confederate Army as a drummer boy at age 15. He later became well known as a politician and businessman. He was appointed president of the Atlantic and North Carolina Railroad in 1886. Winfield also developed the Atlantic Fisheries fish-meal factory. Beaufort Fisheries, a menhaden factory, is located today on Front Street near the end of Taylor's Creek. It is the only plant of its kind still in existence in North Carolina.

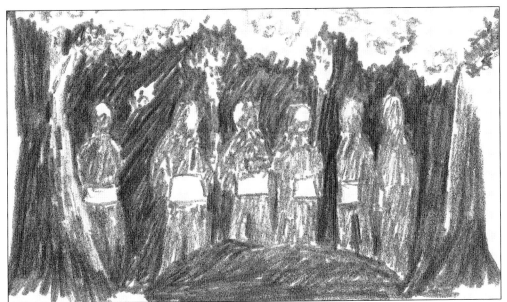

According to legend, William M. Thompson, born in 1850, died by drowning at age 25. He was buried on a September night while the whole town gathered to watch. Masons, in their aprons, moved about making an eerie picture in the light of their flickering wood torches. (Artist's concept of that sad night, ©1998, Mamré.)

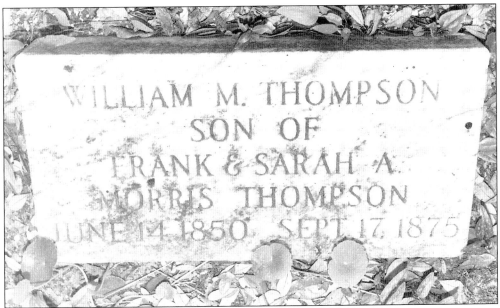

There is little known about this young man. However, it appears that he may be a great-grandchild of William Thomson, who fought in the Revolutionary War. Louise Nelson, of Beaufort, recalls that when a person died, cards were printed with a black border and taken door to door to announce the death.

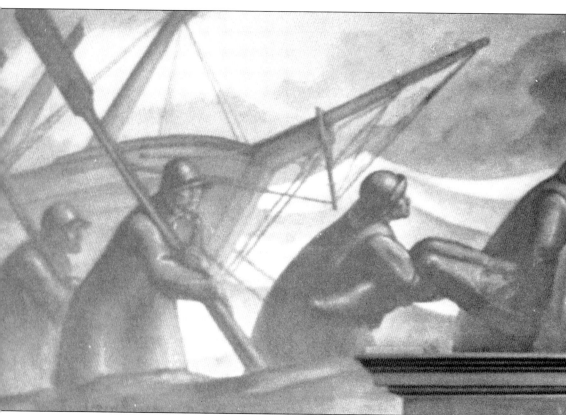

In the winter of 1886–1887, the schooner *Crissie Wright* went aground on Shackelford Banks. It was a severely cold night, with the wind blowing up a storm, when the people living on the Banks saw the ship being beaten about by the pounding surf. A bonfire was lit on the beach as a

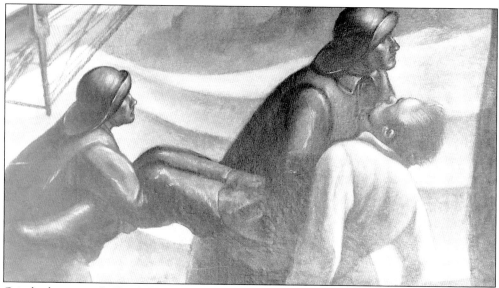

Grimly determined, Shackelford Banks men brought back the dead and one young survivor from the *Crissie Wright*.

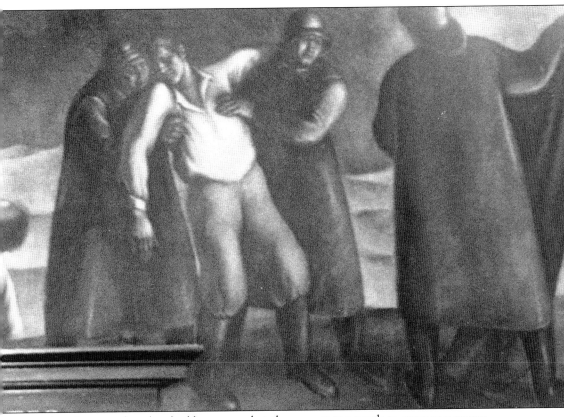

signal to the crew that they had been seen, but the sea was too rough to attempt a rescue.

In the morning, boats from the Banks went out to the *Crissie Wright* to see if there were survivors. Four of the crew had been able to stay on board. They wrapped in sails and lashed themselves to the mast. The only one to survive was a 16-year-old cabin boy. Shielded by the dying bodies of his mates, he was able to survive from the warmth generated by their bodies. The rescuers brought him to shore and placed him on a double bed on the porch of one of their homes. He was laid in the sunshine, covered with quilts, and allowed to thaw out. After three weeks, he left for his home in the North.

The bodies of the others were brought to the Inlet Inn of Beaufort, put in caskets, and held for family members from the North to come and take them home. They were never claimed, so the three were buried together in the Old Burying Ground. Following this disaster, the Cape Lookout Life-Saving Station was established.

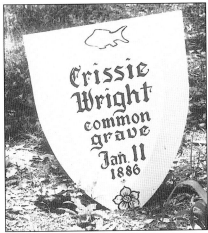

Even today, when the weather turns bitter cold and windy, folks say, "It's the coldest time since the *Crissie Wright* went ashore." The story of these brave men is depicted in a wall mural in the Beaufort Post Office on Front Street.

This marker holds dear the common grave of unclaimed sailors who froze on board the *Crissie Wright*.

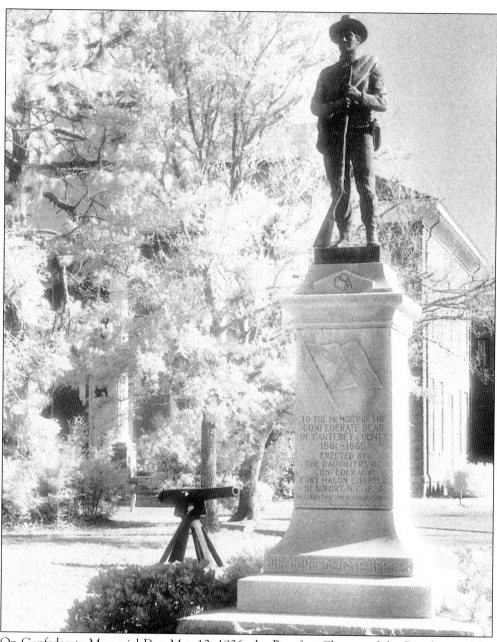

On Confederate Memorial Day, May 10, 1926, the Beaufort Chapter of the Daughters of the Confederacy unveiled this monument on Courthouse Square in Beaufort. The monument consists of a granite base topped by a bronze figure of a Confederate soldier, 6 feet tall, with his knapsack and canteen by his side and hands gripping his musket. Please note, the soldier is facing south.

One inscription reads, "Not even time can destroy heroism," while another states, "To the memory of the Confederate Dead in Carteret County 1861–1865. Erected by the Daughters of the Confederacy, Fort Macon Chapter, Beaufort, NC, 1926." Memorial ceremonies are held at the courthouse every year in Beaufort on Confederate Memorial Day. Flags are placed in the Old Burying Ground on the graves of the war dead as part of the ceremony.

Three

VOICES OF WAR

The form that fills this silent grave
Once tossed on ocean's rolling wave
But in a port securely fast,
He's dropped his anchor here at last.

—Captain John Hill, d. 1878

Acts of daily duty and individual deeds of heroism give insight into the life and times affected by war in this strategically located seacoast county. Staunch determination and courage helped early settlers and their followers to this sandy shore persevere in spite of Indian massacres, invaders from foreign lands, and conflicts at home during "the great unpleasantness," as the Civil War was sometimes labeled. Many participants in these battles are buried in the Old Burying Ground—some with simple stones, others with official government markers. For most of those slain, battle was only a chapter in lives filled with family activities and their own occupations as merchants, fishermen, doctors, and farmers. However, when duty called, most went willingly to support the cause to which their conscience led them.

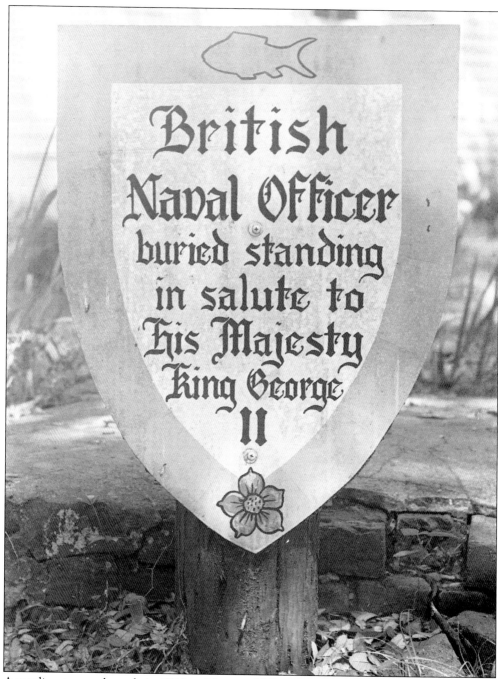

According to one legend, in 1744, a 19-year-old British sailor contracted a terrible malady while at sea. On learning from the ship's captain and doctor that he was indeed dying, he took it bravely with only this one request, "Sir, just put me in my uniform and bury me standing up so I can salute my country in death as I do in life." When the ship reached Beaufort, his request was granted. On his tombstone is written, "Resting 'neath a foreign ground, / Here stands a sailor of Mad George's crown, / Name unknown, and all alone, / Standing in the Rebel's Ground."

Colonel William Thomson (1732–1802) was the highest ranked officer from Beaufort during the Revolutionary War. A landholder and respected town official, he held several responsible appointed positions, including town treasurer, sheriff, and justice on the bench. He participated in the First, Second, Third, and Fourth Provincial Congress in North Carolina. He was generous to his family in his will. He also left an additional 20 pounds with instructions to his executors to choose four of the poorest boys in town and "lay it out in schooling" for them.

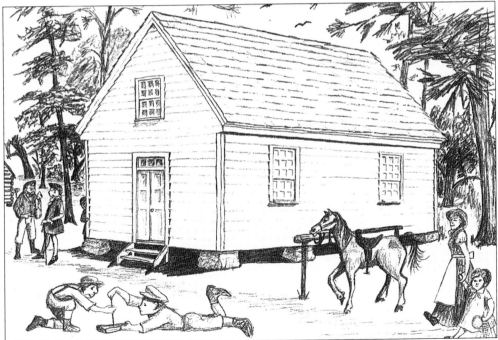

Colonel Thomson was placed in charge of building the courthouse and its subsequent repairs. In his capacity as treasurer of public buildings in Beaufort and county treasurer, Colonel Thomson provided funds in the form of a loan from public money to build the courthouse. (Artist's concept of the courthouse, ©1999, Mamré.)

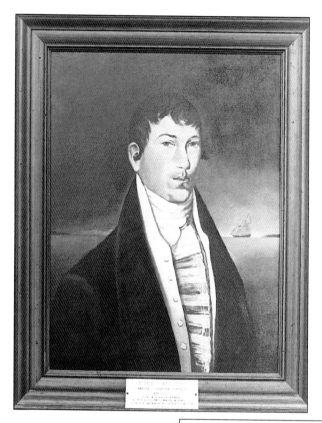

Otway Burns (1775–1850) was one of North Carolina's greatest naval heroes during the War of 1812. He was also a shipbuilder in Beaufort and served two terms in the North Carolina Legislature. Burns served as keeper of the Portsmouth Island Lighthouse until his death.

Following the loss of the colonies, the English Navy was in need of seamen. American ships were boarded on the high seas where men were pressed into service or sent to prison. To combat this activity, the new government of the United States gave sea captains with ships letters of Marque and Reprisal. This allowed them to prey on English shipping without being considered pirates. As a privateer, Burns plundered British shipping between Nova Scotia and South America. His tomb is surmounted by a cannon that was taken from his ship, the *Snapdragon*. This is a model of Captain Otway Burns's ship.

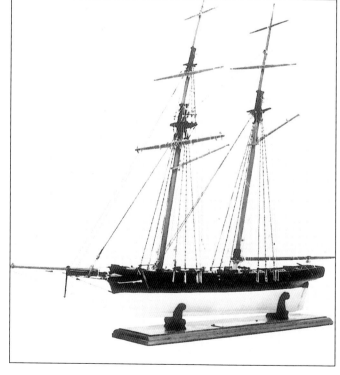

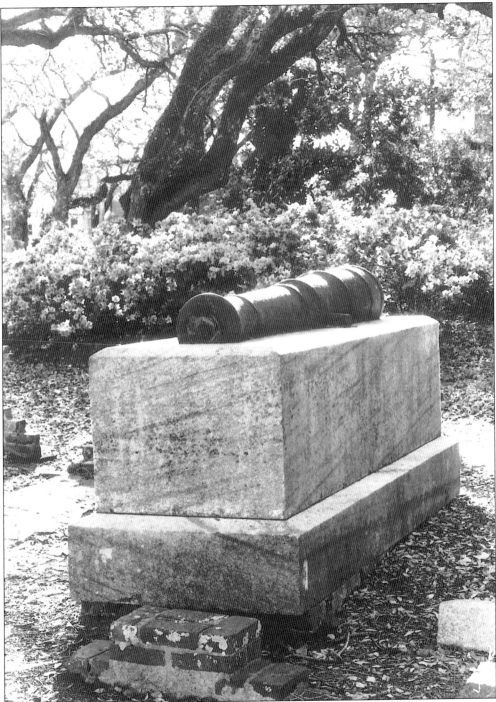

Following his death while keeper of the lighthouse on Portsmouth Island, near Ocracoke, Burns's body was placed in the bottom of a shallow-bottom, centerboard sailboat designed for Carteret County waters. Covered by a piece of jib sail, he was brought to Beaufort for burial in the Old Burying Ground. In 1902, his grandchildren came to Beaufort and erected this monument in his honor.

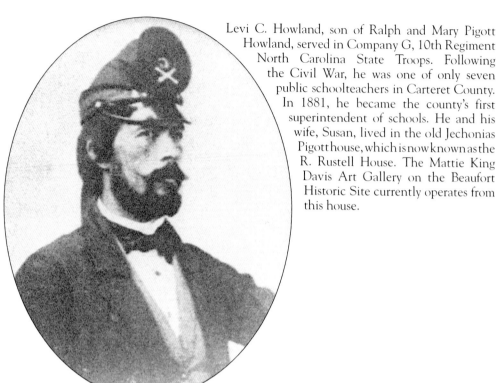

Levi C. Howland, son of Ralph and Mary Pigott Howland, served in Company G, 10th Regiment North Carolina State Troops. Following the Civil War, he was one of only seven public schoolteachers in Carteret County. In 1881, he became the county's first superintendent of schools. He and his wife, Susan, lived in the old Jechonias Pigott house, which is now known as the R. Rustell House. The Mattie King Davis Art Gallery on the Beaufort Historic Site currently operates from this house.

Susan Pigott Roberson, Levi's wife, was the daughter of Malachi Bell and Sarah Ann Pigott Roberson. She and her sisters are credited with having made the flag that Captain Pender raised at Fort Macon in April 1861. Susan and her sisters were tutored by Stephen Decatur Pool at their home in the second block of Turner Street, which today is the Masonic Lodge adjacent to the west side of the Old Burying Ground.

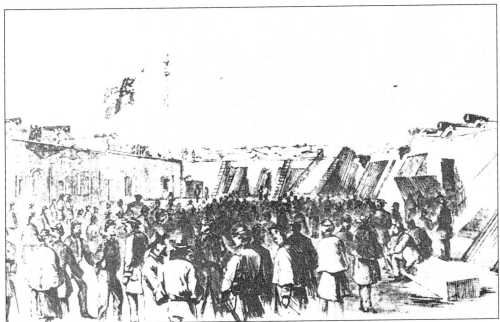

Need for continued protection from invaders from the sea led to the replacement of Fort Hampton—a small masonry fort on Bogue Banks point washed away by storm—with Fort Macon, which has a much sturdier fortification. The fort played an important role in the Civil War and was held at different times by both Confederate and Union soldiers. Pictured is a sketch from *Frank Leslie's Illustrated Newspaper* (May 24, 1862) of the surrender of Fort Macon and the lowering of the Confederate flag on April 26, 1862.

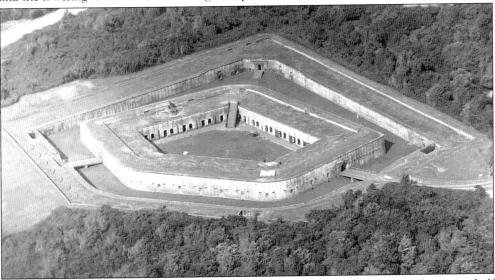

Fort Macon today is one of the most often visited sites in North Carolina with up to a half million visitors annually. Ships leaving the harbor from the Morehead City Port, as well as fishing and pleasure boats, can be seen from the ramparts. Join a tour and hear stories of battles fought, and see the soldiers' quarters dug into the fortified walls of the fort. Learn how townspeople participated by providing the only mail service and offering medical attention for diseases brought on by the damp casements used for troop quarters.

Born in 1819 into a wealthy North Carolina family, Captain Josiah Solomon Pender was a prosperous jeweler, steamship owner, hotelier, and erstwhile soldier. Pender received a West Point appointment in 1835, joining Company A, 1st North Carolina Volunteer Regiment in 1846. On April 14, 1861, he led a group known as the Beaufort Harbor Guards across the harbor and took control of Fort Macon from the only Federal officer there. Pender was dismissed from the army that same year and began using his three steamships as blockade runners in the port of Beaufort.

Pender and his first wife, Maria Louise Williams, had 13 children—most dying in infancy. Maria died in 1861 and, being a devout Baptist, was buried next to her church on Ann Street in the Old Burying Ground. Pender and his second wife had only one son, who died in his teens. Following a fatal bout with yellow fever, Pender died in 1864 and was buried next to his first wife.

James W. Hunt was born in 1794 and came to Beaufort during the War of 1812, in which he served as an army surgeon. Following the war, he bought property upon which the third Carteret County Courthouse had been moved. He built an apothecary shop next door and practiced medicine in Beaufort. Also active in town affairs, he served as justice of the peace and Beaufort commissioner.

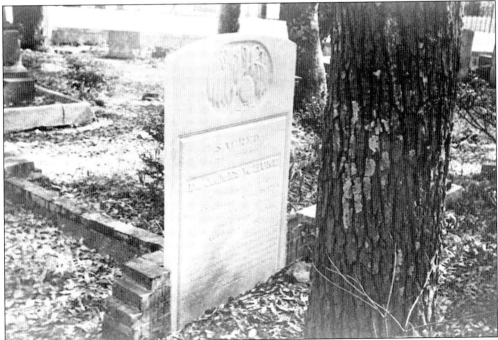

James Hunt had the distinction of having married and died within 24 hours. At age 54, on August 23, 1848, he married his housekeeper, Alice Hancock. He wrote his will and died on August 24, leaving his estate to his new wife. His will left "all his Negroes" to Alice as well as the interest earned on investments made from the sale of the rest of his estate.

I, M.R. Gooding while laying at the R.R.
up the Ogeechee River — July 11" 1862 do he
give a Statement of my unsettled busi
between myself and the House of John F
of Charleston So. Ca,

On first page [...] [...]
a ballance due [...] [...] On
hundred fifty [...] [...] cents
from the said Ship [...] [...], I having
been transferd from her (on the 17" March 18
to the St" Thomas D. Wragg"

On my assuming
Command of the present Ship "T.L. Wragg"
Owners agreed with me, to be paid as folle
One hundred Dollars for Calender Month, Com
on the 18" day of March 1862 and in Additi

The census of 1860 lists Matthew Gooding as 30 years of age and living with his wife, Rebecca, and their one-year-old son, Herbert. Matthew was in service on several ships carrying freight, upland cotton, and Confederate cargo. His wages on board the sailing ship *Gondor* were $100 per calendar month plus 5 percent of the gross amount of all freight, which was to be credited to him at the port of discharge in current funds at that port. He often had part interest in a ship as well. Payment was sporadic at best, and, realizing the uncertainty of his wages and his life, he was concerned that his wife and family be provided for should he die. The above will was written aboard the steamship *T.L. Wragg*, lying by the railroad bridge up the Ogeechee River. Wages had not all been paid in full when Matthew wrote this will stating that "all and every dollar of the foregoing amounts when settled, I wish, and my will is, that it should be paid to my beloved wife, Rebecca Gooding, residing at Beaufort, North Carolina, without reservation."

A blockade runner, Captain Matthew R. Gooding (1830–1863) was reported to be one of the best-remembered figures of the local Civil War patriots. During the War Between the States, Matthew captained the blockade runner *Nashville*. Painted the color of a Hatteras fog and burning smokeless anthracite coal, the long, low-converted sidewheeler was nearly invisible against a wooded shoreline. Gooding and the *Nashville* ran the Federal blockade of Beaufort harbor and helped destroy Yankee commerce ships at sea. Gooding died in January 1863 at the age of 32.

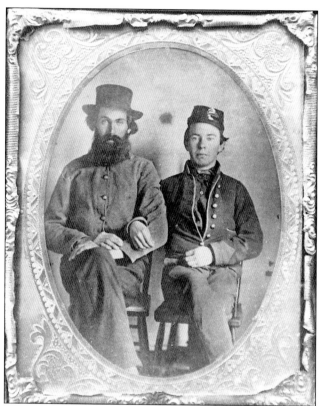

Jechonias P. Willis (1838–1862) was one of four children born to Horatio H. and Abigail Hancock Willis. Jechonias grew up in Carteret County and, at the age of 22, enlisted as a private in Company H, 10th North Carolina State Troops. He was appointed sergeant in early 1862. Jechonias Willis is pictured on the left, and Private Thomas W. Lindsay is on the right.

The Willis House (c. 1820) was built by Horatio Willis. Only half of the intended house was originally built, with enlargement plans for the future. A large church conference was planned, including using the Willis House as a gathering place for visitors. This resulted in pushing the completion date for construction. The house was extensively remodeled and enlarged in 1900 by Ambrose Jones Fulcher.

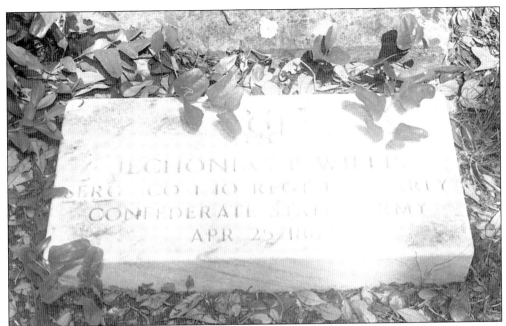

When Fort Macon was captured by Federal troops in 1862, Jechonias Willis was one of two Beaufort men killed. The bodies were brought to their families in Beaufort. It was reported that upon seeing the grieving families and as the pine box containing Jechonias was brought ashore, General Ambrose Burnside shed tears.

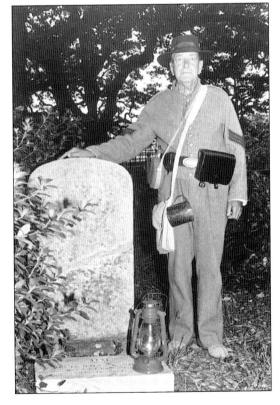

A *New York Times* article reported on May 8, 1862, that at the funeral of Jechonias P. Willis in the Methodist Episcopal Church, Captain Pool rose in the body of the house and paid a handsome tribute to his deceased townsman, eulogizing him as a brave and good man. This picture is of Ralph Willis in Civil War uniform standing beside his grandfather's uncle's grave.

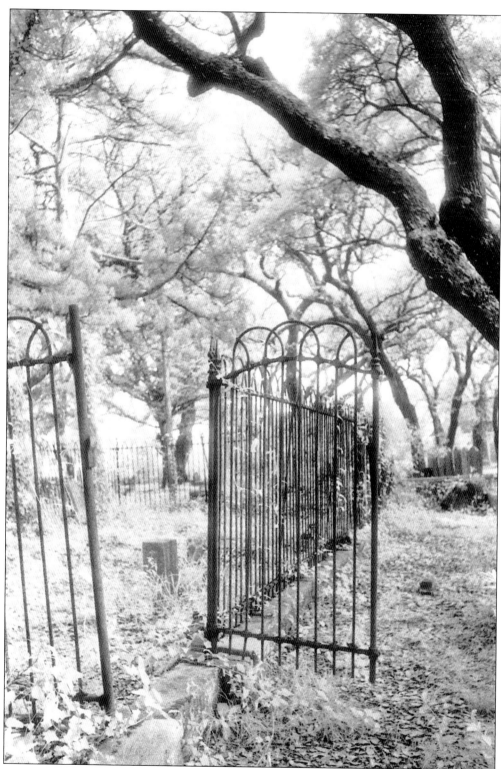

Pictured here is the gate to a private family plot.

Four

HOUR OF SLEEP
FAMILY PLOTS AND CHILDREN'S STORIES

God needed one more little child
Amidst his shining band
And so he bent with his loving smile
And clasped our darling's hand

Mamie Green, d. 1890

Relatives often lived in close proximity to each other for their whole lifetime. Family plots were reserved for members, providing a final resting place spanning several generations. The Duncan/Ramsey, Beveridge, King, and Norcum family plots are examples of this custom in the Old Burying Ground. Sadly, children had a short life expectancy during our country's early times. Inscriptions reflect the special sadness for a young child's death. The yellow fever scourge of 1864 wiped out a substantial portion of the area's population. People who had the means fled the area to escape the disease, and businesses boarded their doors, but to no avail. The tragic story of a Sunday schoolteacher and her entire class dying of yellow fever is part of the history preserved in the Old Burying Ground.

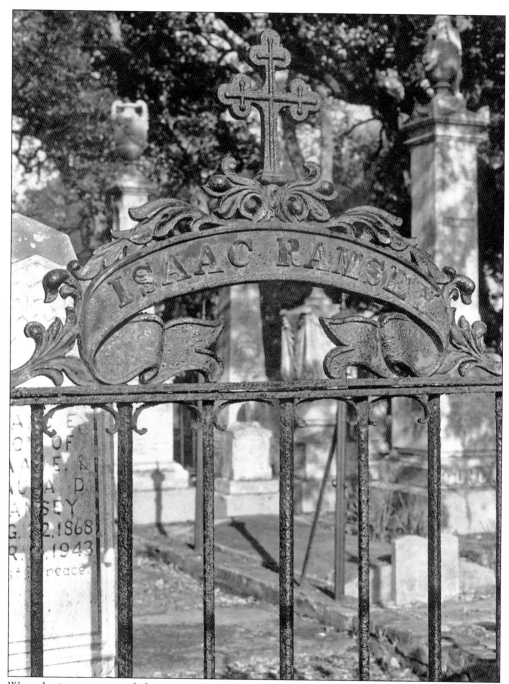

Wrought-iron gates and fences enclose several family plots in the Old Burying Ground. Isaac Ramsey (1804–1878) and his first wife, Charity, had eight children. During the Civil War, Isaac was a merchant as well as a friend of the Levi Woodbury Pigott family and Levi's cousin, Emeline Pigott. She was a well-known Confederate spy and was arrested in 1865 for smuggling information through enemy lines. Isaac checked on this situation. A large and prominent store in Beaufort was closed at the same time, supposedly for complicity—perhaps this was Isaac's store.

Martha Washington Ramsey (Mattie), daughter of Isaac and Charity Ramsey, was born in 1846 and was one of the many victims of the yellow fever epidemic that swept the area in 1864. The monument marking her grave offers comfort in the loving arms of the statue.

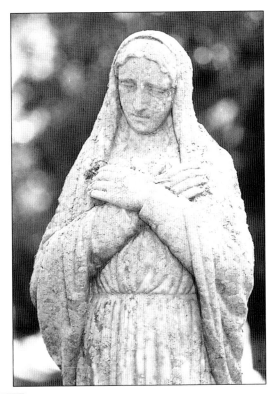

The Beaufort Duncans came from the West Indies. In building the family home in 1728 at the west end of Front Street, John Duncan incorporated architecture from the islands. Ella V. Duncan was the daughter of Thomas Duncan and Alicia Howland Duncan. The monuments in this family plot are some of the most exquisite in the Old Burying Ground.

Legend has it that Joseph King was really Antoine Joaquin (Joe King) Sousa, a small boy who was kidnapped and stowed away in a ship harbored in Portugal that eventually landed in Beaufort. Many King family members are buried in this plot. Their stories are intertwined in the history of Beaufort. As with many families in the Old Burying Ground, descendants still live in Carteret County today. One family (shown in the photo) buried here is Dr. Francis King and his wife, Sara Ward, who had ten children. The measure of this man is noted on his stone, "Mark the perfect man and / Behold the upright for the end / of that man is peace."

Iron work around the Norcum family plot was made by the Patch Company in Boston in 1865. The family came from Edenton, North Carolina, known at that time as Queen Anne's Creek. The gravestones and iron fencing indicate a family of means. The homeplace of the Norcum family was originally on Craven Street in Beaufort, but a few years ago it was moved to Ann Street overlooking Gallant's Channel.

Captain David Liddon Beveridge was born in 1915, son of Captain John Thomas Beveridge and his third wife, Nancy Pigott Beveridge. He led an active life on the sea. Shown here on the North Carolina ferryboat *Governor Hyde*, he traveled between Ocracoke and Swan Quarter. He served, owned, or captained many boats, including the vessel *Wanderlust*; the North Carolina patrol boat *Hatteras*; shrimping vessels named the *Beveridge* and the *Jerry*, for his wife; the Duke University Marine Laboratory research vessel *Eastward*; and the *Dan K. Moore*, a research vessel he helped to design and build for use by the State of North Carolina.

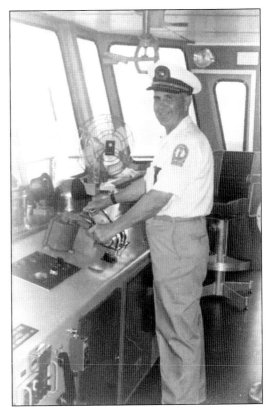

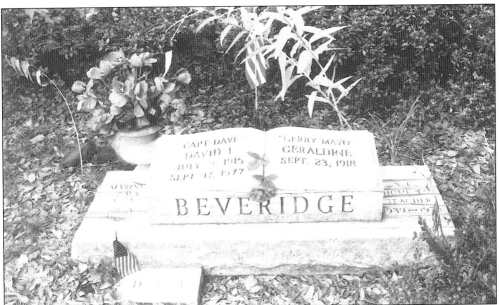

David Beveridge was involved in many local activities. He served on the North Carolina Marine Fisheries Commission and the Beaufort Harbor Commission. Gerry Mayo Beveridge, his wife, is one of the docent volunteers leading tours through the Old Burying Ground. She devotedly cares for his grave to this day.

This little girl was buried in a keg of rum. Her family came to Beaufort from England in the 1700s while she was still an infant. As she grew up, she begged for her father to take her to see her homeland. By promising to bring her back, her father finally persuaded the mother to let their daughter go with him on this sea voyage. Unfortunately, the child died on the way back to Beaufort. Keeping his promise to her mother, her father purchased a keg of rum from the sea captain and sealed his daughter inside. On arrival in Beaufort, the little girl was buried still in the rum keg. Children today are touched by her story and often leave small gifts of shells, toys, and coins on top of her grave.

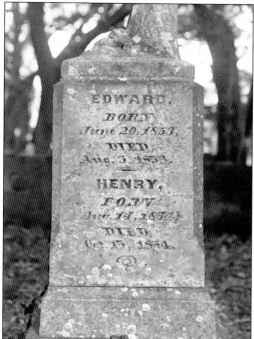

All four children of Charles R. Thomas and Emily Pitkin Thomas died between 1853 and 1860. Listed are Edward, Henry, George, and Richmond. Charles was an attorney living in Beaufort. The census of 1860 lists no children, only nieces and a nephew. The tree cut off near its roots tells the sad story of these children whose lives were often ended before they could make their mark in the world.

Mattie May Yates and her brother, Isaac Edwin, are buried in the Duncan/Ramsey plot. Isaac was born in 1859 and died in 1860. Mattie's inscription reads, "Age 2 yrs. 2 mos."

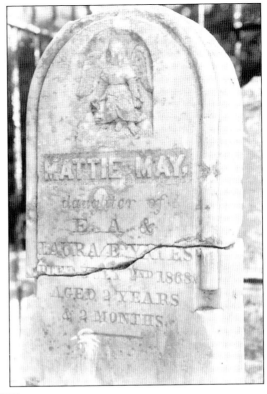

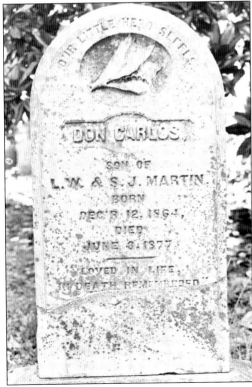

"Our little hero sleeps" are the loving words atop the stone of Don Carlos Martin, son of Dr. Lafayette Washington Martin and Sara J. King Martin.

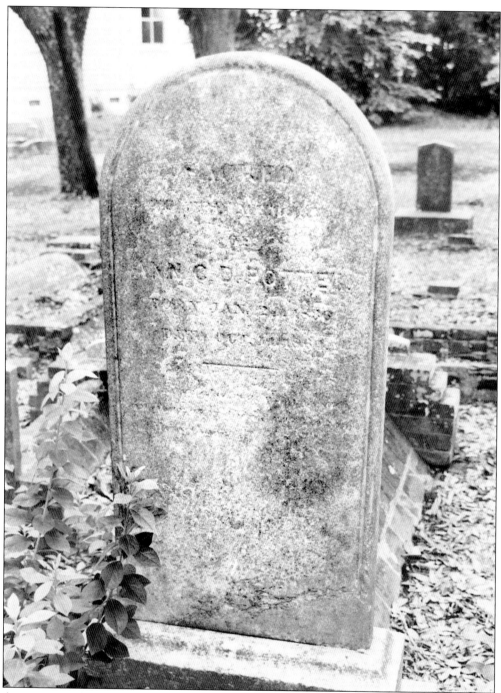

An entire Sunday school class of the Ann Street Methodist Church including the teacher, Ann C. Potter, died of the yellow fever epidemic of 1864. The students were Ann Gibbs, age 17; Mattie W. Ramsey, age 18; Annie Dill, age 16; Ella V. Duncan, age 13; Alice V. Murry, age 9; Ruth W. Hatsel, age 6; David W. Morse, age 13; John Chapman, age 14; Johnnie E. Sabiston, age 6; and Charles S. Sabiston, age 5. Ann Potter's inscription aptly reads, "Be ye also ready for is such / an hour as ye think not, the Son / of Man cometh."

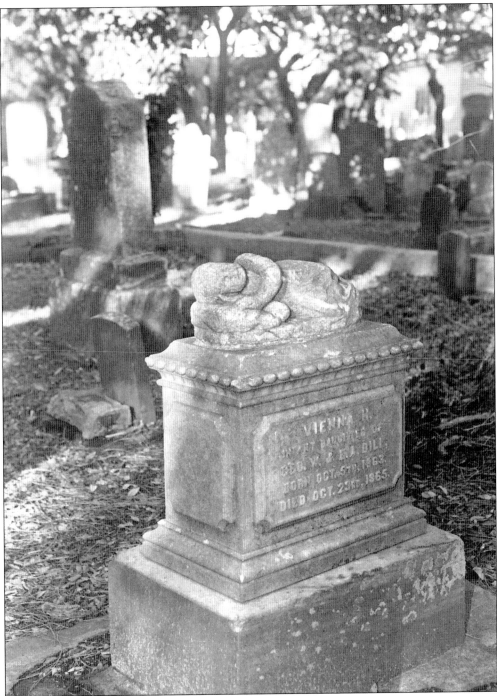

Vienna Dill was only two years old when she succumbed to yellow fever. Her parents, George W. and Elizabeth Thomas Dill, buried her in a glass-topped casket. Local legend has it that her grave was dug up by vandals. Her little body was still intact until the vandals opened the casket—at which time the body disintegrated. The little sleeping child on her stone indicates eternal rest.

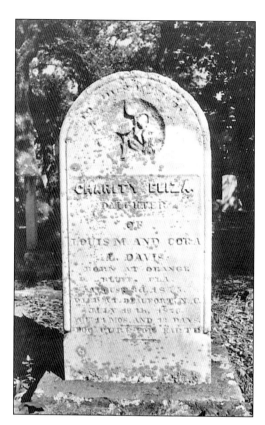

"Too pure for earth" is the sentiment for Charity Eliza Davis, who lived only one year (1875–1876). She was the daughter of Louis M. and Cora L. Davis.

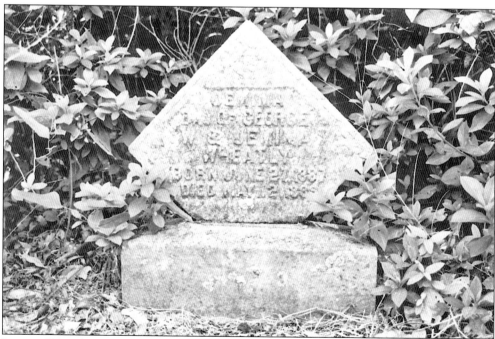

Jemima Wheatley was born in 1887 and died two years later in 1889. She was the daughter of George W. Wheatley Jr. and Jemima Sewell Wheatley. This unusual stone marks her grave.

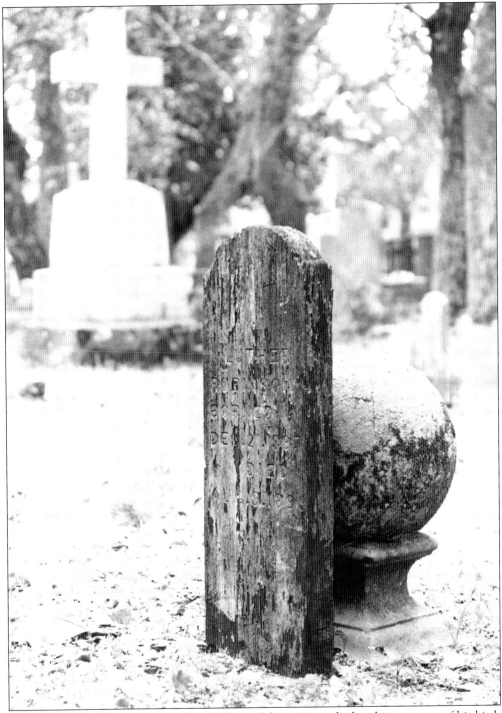

Luther Robinson, like so many other children of those times, died within one year of his birth (1897–1898). A wooden marker accompanied by an unusually large ball marks his grave.

Five

CHISELED MEMORIES
IN ART AND POETRY

She lived as peaceful as a dove
She died as blossoms die
And now her spirit floats above
A seraph in the sky.
Weep not I take these little lambs
And lay them in my breast
Protection they shall find in me
In me be ever blest.

Evelyn Duncan, d. 1855

Parting thoughts for loved ones were often beautifully portrayed in symbolic art carved on monuments, inscriptions about the person, stained-glass windows dedicated in their memory in churches, and in the ongoing custom of placing flowers on the grave. A sampling of inscriptions dedicated to a soldier, physician, brother, minister, woman, teacher, family man, and children are used to tell their place in the life of the community. Although there are different interpretations to various symbols, these carvings had a special meaning of hope for eternal life and indicated sorrow for the passing of a loved one. Many such symbols are used in the Old Burying Ground and add beauty to this special place.

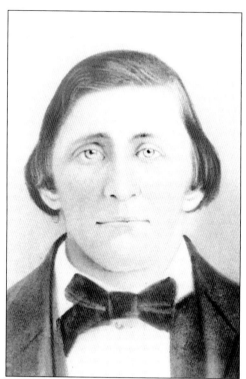

Captain Thomas Thomas (1816–1898) owned sailing vessels and a wharf on the south side of Front Street in Beaufort. He and his wife, Martha Dudley Murray Thomas, had 16 children, but only 5 lived to become adults.

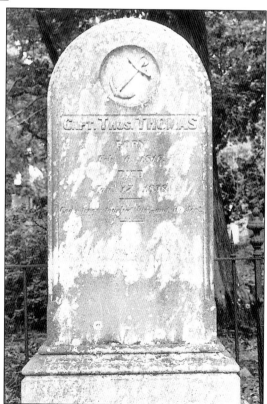

An anchor symbolized that Thomas was a seaman and spiritual anchor for the family. Thomas's inscription reads, "God's finger touched him—and he slept."

72

Captain John Hill was born in 1817 on Portsmouth Island. He served as postmaster on the island from 1868 to 1869. His first three wives were buried on the island in their yard. He and his fourth wife had five children.

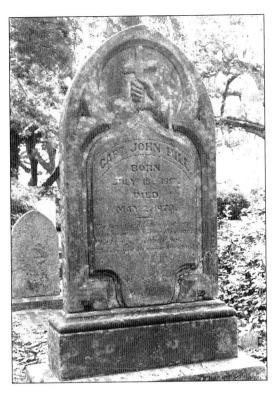

Hill built his house on Portsmouth Island in 1839. In the early 1870s, he moved his family and his house to Beaufort. The house was poled down the inland waterway along Core Banks, through the Straits, down Taylor's Creek to a spot at the west end of Front Street called Duncan's Green. John Hill died in 1879 at the age of 62. When his house was moved a third time, some of the bricks from the chimney were used to repair his tombstone. His inscription reads, "The form that fills this silent grave / Once tossed on ocean's rolling wave / But in a port securely fast, / He's dropped his anchor here at last."

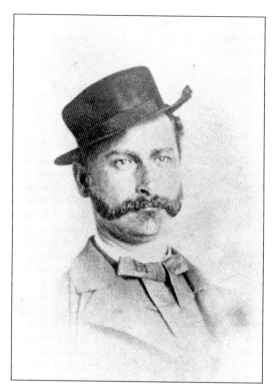

Dr. James Manney, a Beaufort physician, was honored with this lengthy epitaph: "In his public and private relations in life / his conduct was ever prompted by the motives / of the patriot and philanthropist, and marked / by a high sense of moral rectitude, and while he / laboured with zeal in the discharge of the duties / of his profession, he was ever distinguished for / his devotion to the welfare of the community / and his ardent love of his country. / He passed through the valley and shadow / of death with Christian resignation and, it / is humbly hoped, now reposes in peace with / his Redeemer."

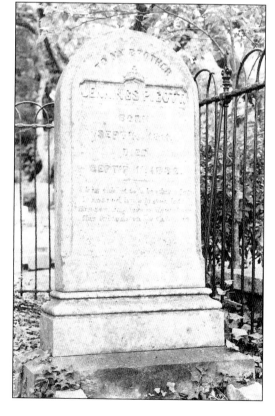

Jennings Pigott was born in 1811 and died in 1882. The touching thoughts of his sister mark his stone, "This tablet to a brother's love, / Is reared by a sister left / His soul in bliss is now above / His friends on earth bereft."

A physician in the Confederate Army during the Civil War, Lafayette F. Leecraft died in 1864 while he was still in service. There are two tales concerning his tombstone. The first is that Lafayette was a member of a peculiar doctors' fraternity that would not allow a marker to extend above a certain height. The second tells that his family had the monument broken to symbolize that his life was cut short. The "All that is light must fade" inscription seems to support the second story.

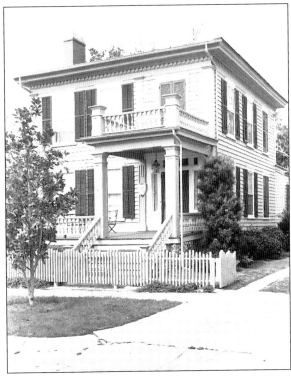

This is one of three Leecraft houses, built side by side on Ann Street, by Benjamin Leecraft. The small front porch and flat roof on each distinguish his architectural style.

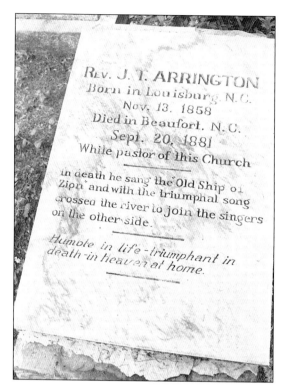

The Reverend Joseph T. Arrington (1858–1881) came to Beaufort to serve at Ann Street Methodist Church. He died while serving as the church's minister. The words on his stone reflect his faith in eternal life, "In death he sang, 'The Old Ship / of Zion' and with the triumphal song / crossed the river to join the singers / on the other side. Humble in life—triumphant in death / in heaven at home."

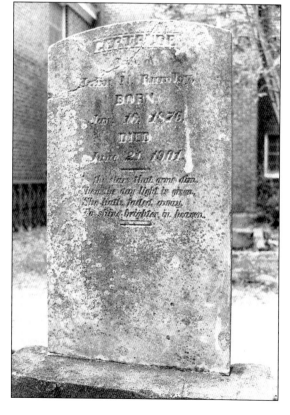

Gertrude Rumley was born in 1876 and died in 1901. The former Gertrude Wheatly married John N. Rumley in 1897. Her inscription reads, "As the stars that grow dim / When the daylight is given / She hath faded away / To shine brighter in Heaven."

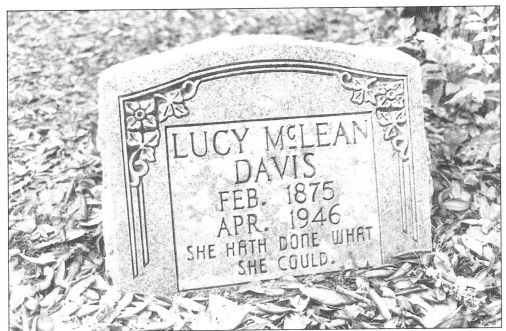

This concise inscription seems to say it all, "She hath done what she could." What more could be said than these words for Lucy McLean Davis (1875–1946).

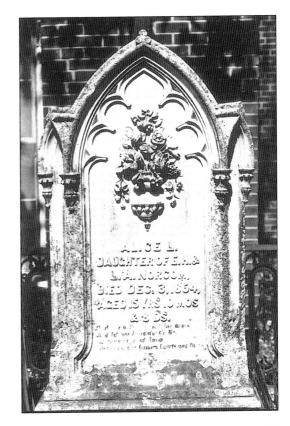

Permanently etched flowers mark the grave of Alice L. Norcum, who lived "15 years, 6 months and 8 days," and her tomb reads, "Fold her, O Father in thine arms, / And let her henceforth be / A messenger of love / Between our human hearts and thee."

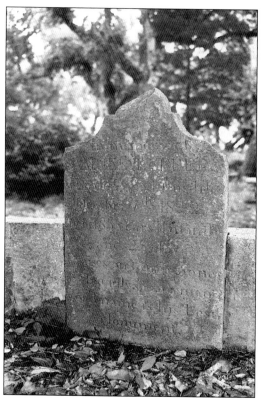

In 1764, Samuel Leffers came to Carteret County from Hempstead, New York, to fill the teacher's position for two schools. As the school term was only three months long, he was able to cover two locations in St. John's Parish, one in Beaufort and the other in Straits. In addition to being schoolmaster and a planter, he was the local surveyor, town and court clerk, and an importer. He lived up to the inscription on his stone, "Praises on tombstones are but idly spent; / A man's good name is his best monument."

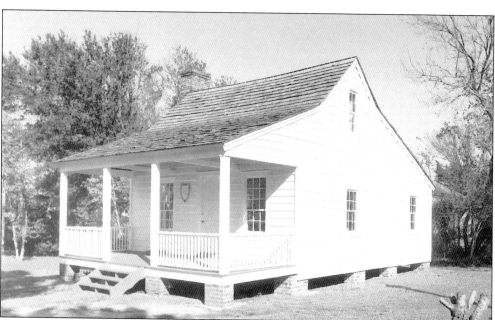

Samuel Leffers's cottage (c. 1778) has been restored and is located on the Beaufort Historic Site. The house, displaying the typical early Beaufort roofline, hosts schoolchildren during Harvest Time each fall and is also open year-round to the public for docent-led tours by the Beaufort Historical Association.

Captain Christian Wulff was born in 1810 in Copenhagen, Denmark. Serving in the Royal Danish Navy, he contracted yellow fever while visiting Beaufort. His sister was contacted when he died. She had his stone made in Denmark and shipped to Beaufort. Wanting to see the stone and his place of burial, she left Denmark to come to Beaufort. However, the ship on which she traveled caught fire en route and was totally destroyed, thus doubling the tragedy. These words she had engraved for her brother, but never saw, "He is not here but is risen."

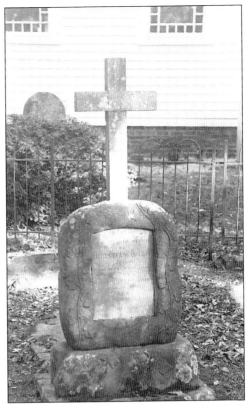

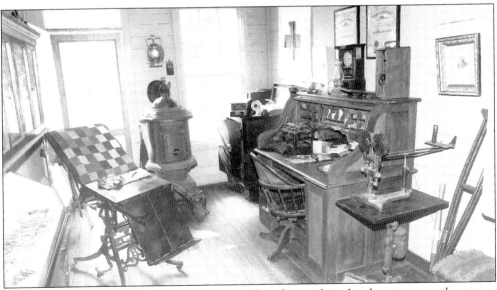

Dr. Joseph Benjamin Davis set up practice in Beaufort within the drugstore now known as the Apothecary Shop and Doctor's Office (c. 1859). This restored building, on the Beaufort Historic Site, is furnished with many original bottles, prescriptions, and instruments used in early county medicine. Dr. Davis's horse was a familiar sight in Beaufort, as he not only visited patients, but hauled both the fire wagon and the garbage wagon. Dr. Davis is remembered as "A kind loving husband and father, / A poor man's friend."

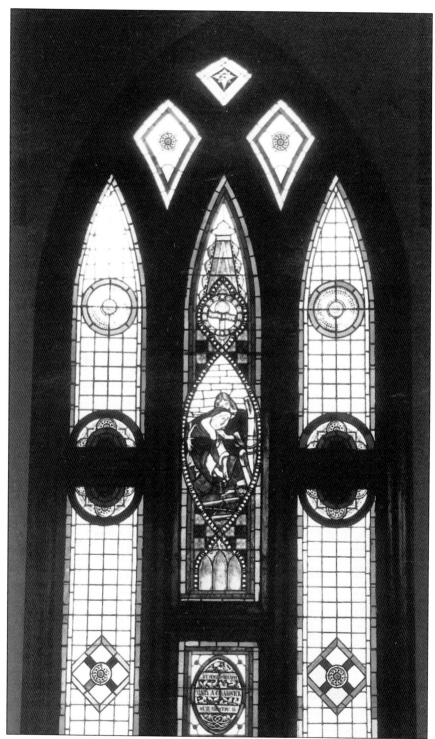

This stained-glass window in Ann Street Methodist Church overlooks the Chadwick family plot in the Old Burying Ground. The window is "IN MEMORIAM / MARY A. CHADWICK / OUR MOTHER."

A little lamb often symbolized the death of a young child. Sometimes only the first name of the child was given, as parents knew their own child, not thinking that years later others would want to know more about the child's history. Here is Little Laura, died June 10, 1865, "aged 6 months and 28 days," her final words reading, "Of such is the kingdom of heaven."

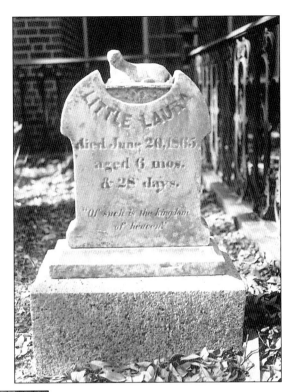

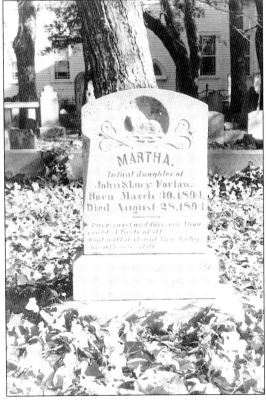

Martha, infant daughter of John and Lucy Forlaw, was born March 30, 1894, dying less than six months later. Her marker is inscribed with the following: "Pure, sweet and fair, ere thou / couldst taste of ill, / God willed it and thy baby / breath was still."

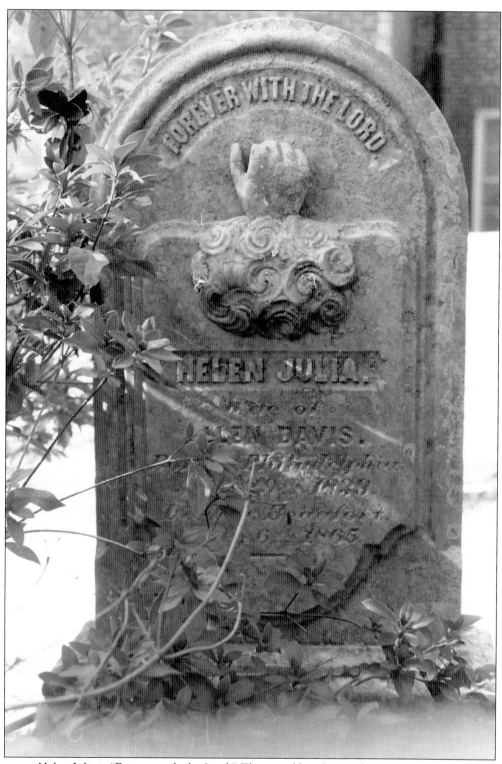

Helen Julia is "Forever with the Lord." The raised hand is reaching up to Heaven.

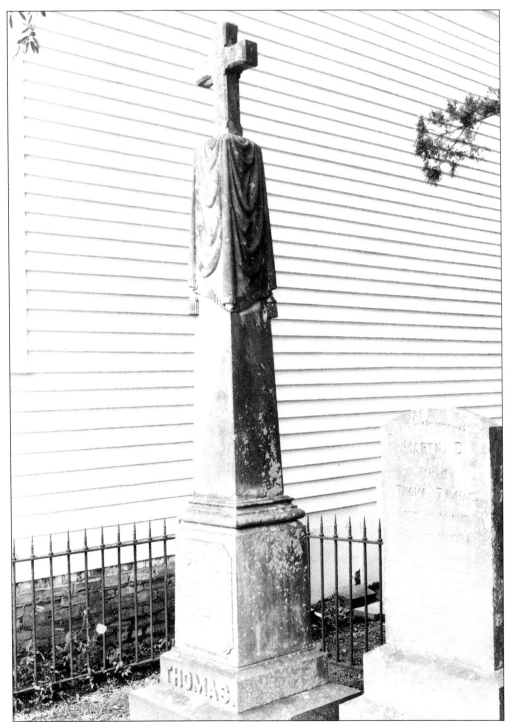

The cross, often seen on stones, reflects religious belief. On this monument of Charles Thomas, the cross combined with a draped shroud indicates mourning, and his inscription reads, "Asleep in Jesus, Oh how sweet / To before such slumber meet! / With holy confidence to sing / That death hath lost its venomed sting."

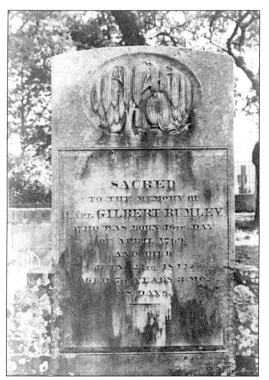

A weeping willow is symbolic of mourning, and here adorns the stone for Captain Gilbert Rumley. An old superstition foretells that if the branches of a weeping willow tree touch the ground, a death will occur in the family.

SACRED
TO THE MEMORY OF
Capt. GILBERT RUMLEY
WHO WAS BORN 16th DAY
OF APRIL 1769
AND DIED

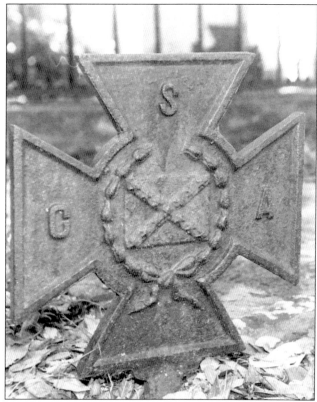

The Maltese Cross is sprinkled throughout the Old Burying Ground marking the graves of Confederate soldiers. Each year, on Confederate Memorial Day, flags are placed on these graves and taps is played to honor these dead.

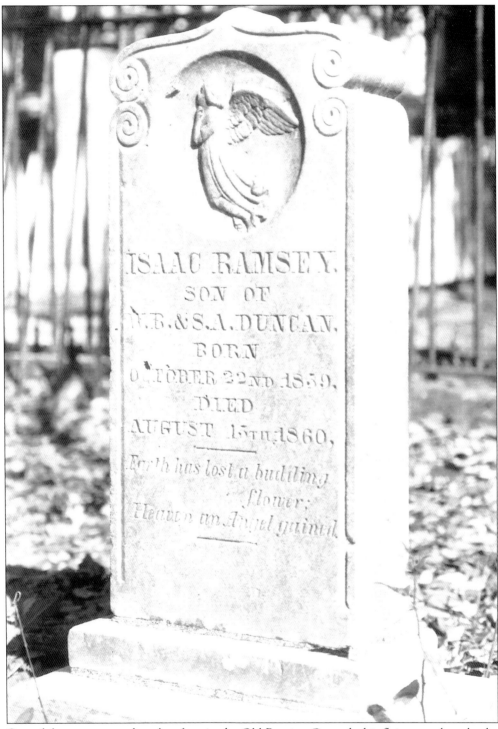

ISAAC RAMSEY.
SON OF
N.B. & S.A. DUNCAN.
BORN
OCTOBER 22ND 1859,
DIED
AUGUST 15TH 1860,

Earth has lost a budding
flower;
Heaven an Angel gained.

One of the many carved works of art in the Old Burying Ground, this flying angel marks the stone of Isaac Ramsey Duncan, not only indicating grief, but also rebirth.

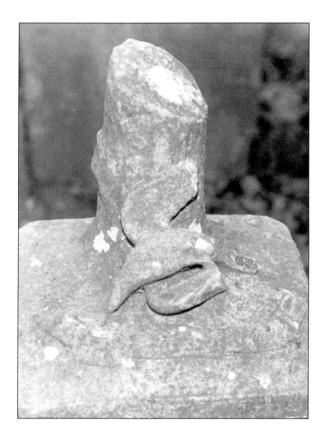

A dead bird, shown here, or a dead tree often broken in half symbolizes a life cut short by death.

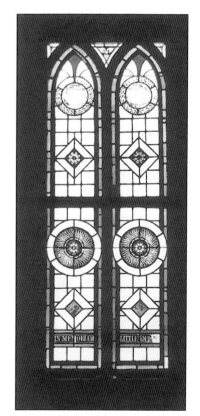

These stained-glass windows in the Ann Street Methodist Church are in loving memory of "Little Em Davis."

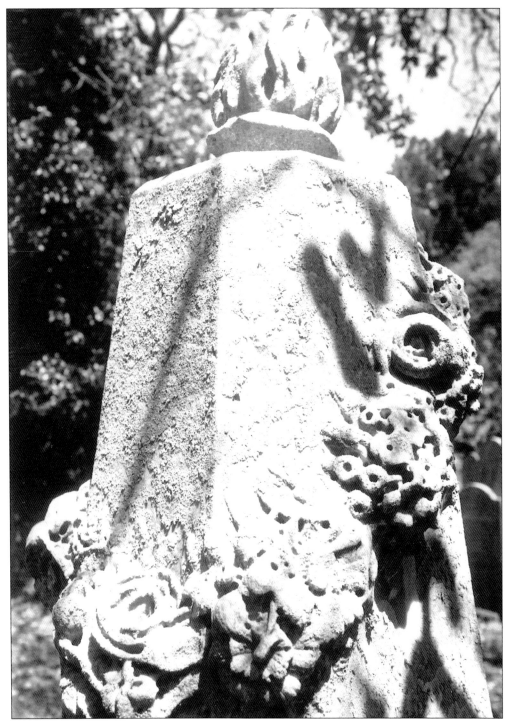

Here lies Bettie G., consort of Bendix Lowenberg, born November 19, 1835, and died October 21, 1864. This is one of the more ornate markers in the Old Burying Ground—an obelisk draped with a garland of flowers for mourning and topped with flame, indicating the hope for eternal life.

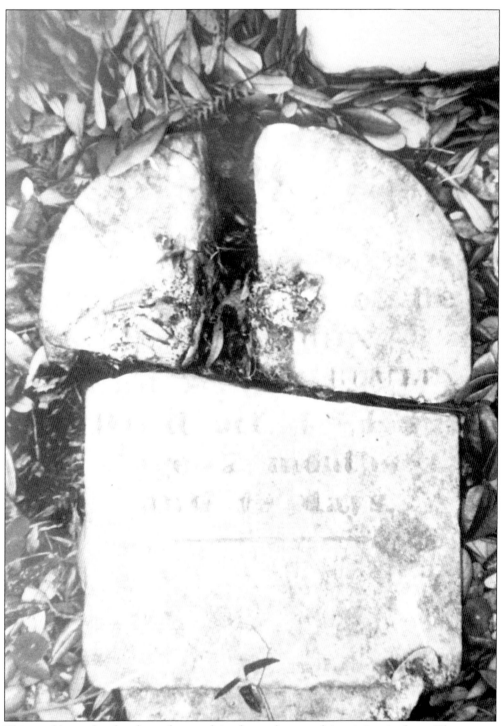

This marble marker has been fractured in three places and is missing its base. The repairs included using threaded nylon rods and epoxy to assure proper alignment and stability. The marker was also in the wrong location and had to be correctly placed in the Old Burying Ground.

Six

PRESERVING OUR HERITAGE

The first rule for cemetery preservationists is to do as little as possible. The second rule is to use the gentlest possible methods for repair and restoration. Some of you reading this chapter may have old family grave markers that you want to preserve, but are not sure of the proper methods. This chapter offers a few examples of work done in the Old Burying Ground by Ruedrich and his crew of Ruedrich Restorations in Bunn, North Carolina. Markers in the Old Burying Ground are made of wood, marble, granite, and brownstone. Concrete was sometimes used as a base. In addition, brick held with mortar often topped the graves.

Moisture, lichen and other vegetation, dirt, wear and tear by visitors in the Old Burying Ground, and hurricane damage all added to the deterioration of the markers. There are so many variables to consider in repairing a marker that it is usually wise to consult a professional before attempting to do the work yourself and risk increasing the damage. The adage in commercials, "don't try this at home," applies here. A complete condition assessment and restoration proposal was made by Ruedrich Restorations to the Beaufort Historical Association, followed by completion of the proposed work plan. Volunteers from the Old Burying Ground Committee, working under the guidance of Ruedrich Restorations, also spent many hours in the delicate and tedious cleaning of these markers.

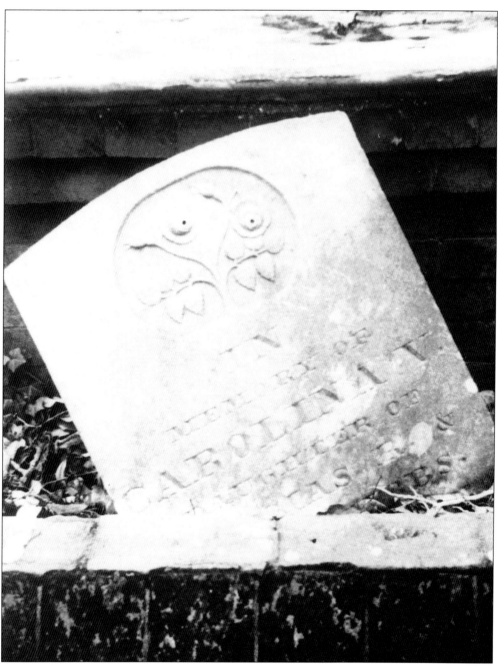

Markers that have been left in disrepair for some time are often not only broken, but missing parts of stone. Look around the area carefully as pieces can be found quite a distance from their original location. This arched-top marble tablet is fractured and is missing a piece. It was rejoined to its base with stainless-steel pins and epoxy. The missing section was recast using Jahn mortar compound.

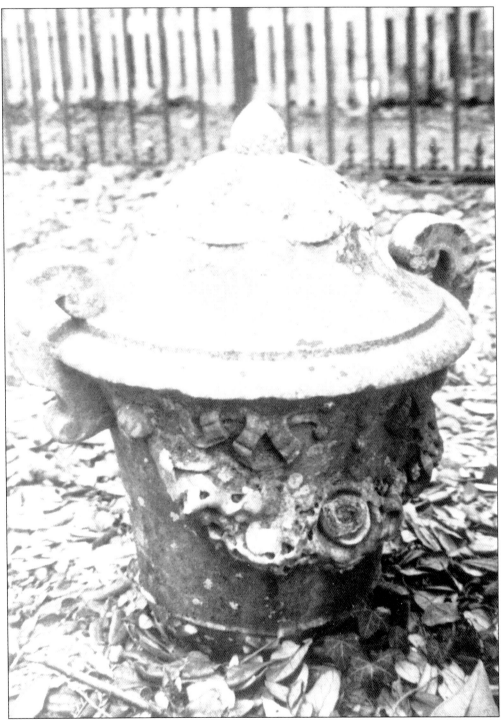

Fortunately, this urn was not severely damaged when it fell from the top of an obelisk in the Duncan plot. It is a lovely two-handled urn with a swag of ribbons and flowers. The urn was reset with epoxy, and a stainless-steel pin was inserted in the base to ensure that the alignment was correct and the urn was stable.

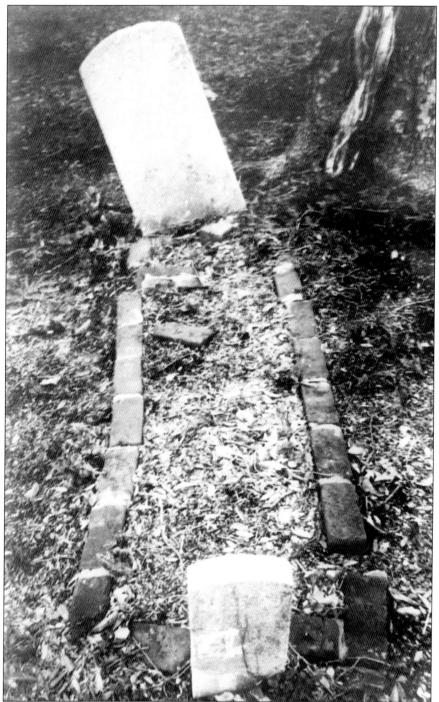

Many plots are either lined with brick or have a brick-vaulted cover over the plot. If the mortar between the brick has dissolved, the vault will be open to deterioration from rain and other moisture. Here the white, arched-top, marble tablet headstone is intact but is precariously leaning and in danger of further damage by falling. The tablet was reset plumb and level to the ground.

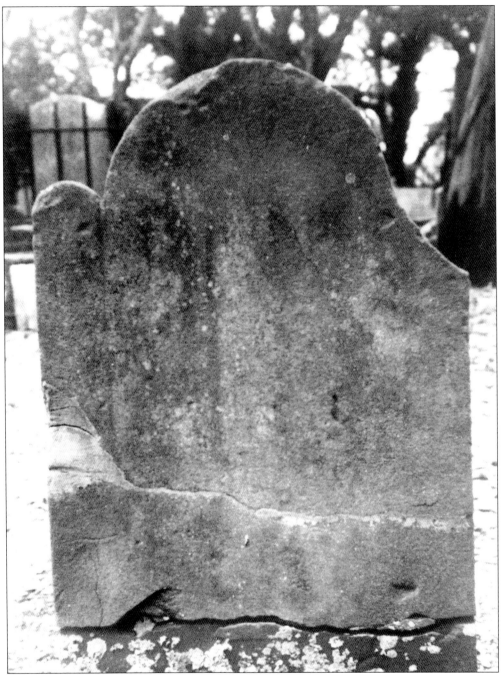

This scroll-topped brownstone tablet is an example of former repairs poorly done. The compound fracture toward the bottom of the tablet is not stable, and the repair site is quite noticeable. This compound fracture was re-secured with epoxy using threaded nylon rods. The void along the fracture was filled with Jahn mortar compound. A complete copy of the "Condition Assessment and Restoration Proposal for the Old Burying Ground" prepared by Ruedrich Restorations, detailing overall marker damage and repair recommendations, is on file in the offices of the Beaufort Historical Association.

BIBLIOGRAPHY

The American Annual Cyclopedia & Register of Important Events. New York: Appleton & Co., 1866.

Beaufort Historical Association Archives. Old Burying Ground records compiled by Barbara O'Neill and Mamré Wilson and members of the Old Burying Ground committee members, available at the Beaufort Historical Association. (Unpublished)

Branch, Paul Jr. *The Siege of Fort Macon.* Self-published, 1995.

Daughters of the American Revolution Manual.

Fisher, P.W. *One Dozen Families.* New Bern: New Bern Historical Society, 1958.

The Heritage of Carteret County, Volumes I and II. Carteret Historical Research Association, 1982.

Kell, Jean Bruyere (text), and Karen Safrit (photographer). *Historic Beaufort, North Carolina.* Self-published, 1977.

Lefler, Hugh, editor. *A New Voyage to Carolina by John Lawson.* Chapel Hill: UNC Press, 1967. Morison, Samuel Eliot. *The European Discovery of America, the Northern Voyages.* Oxford University Press, 1971.

Perdue, Theda. *Native Carolinians: The Indians of North Carolina.* Raleigh, NC: Division of Archives & History, North Carolina Department of Cultural Resources, 1985.

Ruffner, Melissa with Bridge Ruffner. *Arizona Territorial Sampler: The Food and Lifestyles of a Frontier.* Prescott, AZ: Primrose Press, 1982.

Sandbeck, Peter. *Beaufort's African-American History and Architecture.* Unpublished report to the Town of Beaufort and the Historic Preservation Commission, 1995.

Sanders, Rebecca Willis. *Early Marriages, Marriage Bonds and Censuses.* Morehead City. Available at the Carteret County Public Library. (Unpublished)

Wilson, Mamré Marsh. *A Researcher's Journal: Beaufort, North Carolina & The Civil War.* Self-published, 1999.

ABOUT THE AUTHORS

This book has been the collaborative effort of Marilyn Harris Collins, Diane Hassler Hardy, and Mamré Marsh Wilson. Each person offered her special creative talent to this project. Diane Hardy is a professional and award-winning photographer. She received her B.A. from Duke University and has taken numerous photography courses from Northern Virginia Community College, Carteret Community College, and Anderson Ranch Art Center in Colorado. Volunteering on a regular basis for the Beaufort Historical Association, North Carolina Maritime Museum, and Crystal Coast Habitat for Humanity, plus preparing various gallery exhibits, keeps her busy. Examples of juried shows include participation in the Southeastern Spectrum '98 exhibit in Winston-Salem, North Carolina; Magic Silver Show (1996) in Murray, Kentucky; and CCAA '96, '97, and '99 Annual National Competition in Kinston, North Carolina. The North Carolina Seafood Festival chose her images of fishermen for their storefront poster in 1997 and 1998. Her best-known solo work was titled, "Mullet Season: A Bogue Banks Tradition" at the North Carolina Maritime Museum in Beaufort. Except where noted on the Photograph Donor page, all photographs were taken by Diane Hardy.

Mamré Wilson is a researcher, writer, and artist with very diverse talents. She conducted all the research upon which this book is based. She received her A.A. from Centenary College for Women and a certificate of completion of four years from the Education for Ministry program, School of Theology, University of the South. As a volunteer for the Beaufort Historical Association and staff team member responsible for coordinating oral history and archives for the association, Mamré is also the recorder in word and drawings of the 1796 courthouse restoration process on the Beaufort Historic Site. The courthouse is undergoing restoration to its original configuration under the auspices of the North Carolina Department of Archives and History, a volunteer Courthouse Committee under the direction of Kathryn Cloud, and Cullen Restoration and Construction Company. Currently being printed is a new book by Mamré, *A Researcher's Journal-Beaufort, North Carolina & the Civil War*. Mamré's artwork includes book illustrations (some included in this book), notecards, commissioned historic house plaques, hand-painted house replicas, and framed lined drawings of historic buildings.

Marilyn Collins is a writer, marketing consultant, and recently the executive director of the Beaufort Historical Association. Prior to this position, she was the associate executive director of the National Cathedral Association in Washington, D.C. On this book, she was responsible for the writing, layout, photo selection, and liaison with the publisher. Former owner of Wilson Collins Marketing and Management Consultants, Inc., Collins represented such clients

as county-wide economic development organizations, major commercial developers, and nonprofit organizations. Also owner of Harris Sager Publishing Corporation, she produced an annual travel *Guide to Antique Shops*, covering the Mid-Atlantic states. She is the author of various newspaper and magazine articles as well as producing numerous brochures, directories, and corporate marketing studies. Her B.A. is from Carson-Newman College with additional graduate courses from the University of West Florida.

PHOTOGRAPH DONORS

We thank the following individuals and associations who granted us permission to reprint their photographs. All other photographs were taken by Diane Hardy.

Arizona Archives (page 39)
Mrs. Geraldine Mayo Beveridge (page 63)
Beaufort Historical Association (pages 17, 26, 27, 53, 60, 70, 81, 82)
Paul Branch, Ranger III, Fort Macon (page 56)
Carteret County Historical Society (pages 18, 19, 24, 35, 50, 51)
Jean Bruyere Kell (pages 15, 26, 33)
Ward King (page 62)
North Carolina Division of Archives & History (pages 16, 31, 35)
North Carolina Maritime Museum (page 48)
Tom Rady (pages 24, 36)
Ruedrich Restorations (pages 88, 90, 91, 92, 93)
Rocky Mount Telegram (page 52)
Julia Thomas Sebes (pages 39, 72, 74)